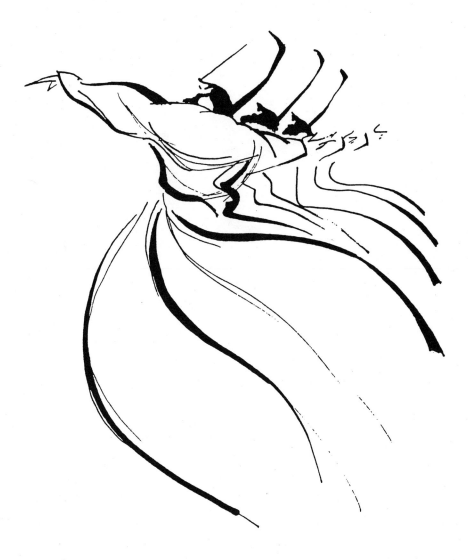

شمس تبریزی بیا کز لطف خود

شوق‌ها در عاشقان افکنده‌ای

Shams-e Tabrizi biyaa, kaz lotf-e khod
Shoghhaa dar aasheghaan afkande'i

*shams of | tabriz | come/appear | because of | kindness/grace of | yours*
*enthusiasm/passion | in the | lovers | you have evoked*

Appear O Shams-e Tabrizi, your boundless grace
Has enraptured the lovers on the path.

# RENDING THE VEIL
## LITERAL AND POETIC TRANSLATIONS OF RUMI

by SHAHRAM T. SHIVA
PREFACE BY PETER LAMBORN WILSON

HOHM PRESS

February 1995, First Edition
© Copyright 1995, Shahram T. Shiva

Printed in The United States of America.
ISBN: 0-934252-46-7

Library of Congress Cataloging-in-Publication Data

Jalāl al-Dīn Rūmī, Maulana, 1207-1273
   [Poems, English & Persian, Selections]
   Rending the veil : literal and poetic translations of Rumi / by
Shahram Shiva : preface by Peter Lamborn Wilson. --1st ed.
   p.    cm.
   Includes bibliographical references.
   ISBN 0-934252-46-7 : $27.95
   1. Jalāl al-Dīn Rūmī, Maulana. 1207-1273--Translations into
English.   I. Shiva, Shahram.   II. Title
PK6480.E5S45   1995
891'.5511--dc20                         94-36971
                                          CIP
                                          NE

Published by Hohm Press
P.O. Box, 2501, Prescott, AZ 86302
(602) 778-9189

Cover picture: *Sufis In Ecstasy* (c. 1650), attributed to Mohammad Nadir-al-Samarqandi.
Used by permission of The British Library.

Frontspiece: *Erik Vilet*
Text Calligraphy: *Massoud Valipour*
Illustration p.xxix: *Es. Rouya*
Design and Typesetting: *Kim Johansen, Pièce de Résistance Ltée.*

*To the bright spirits of*
*Soleyman Tadayyon Shiva &*
*Sheila Shiva*

# ACKNOWLEDGMENTS

A thousand gratitudes to the following:

- Khanum Naz Tadayyon Shiva
- Gurumayi Chidvilasananda, for support, encouragement, and for turning my vision within and to the East.
- Pir Vilayat Inayat Khan, for support, and kind review of this book.
- Ismail Merchant, for his generosity.
- Jonathan Star, for encouragement and feedback on the English.
- Rita Lefkowitz, for feedback on the English.
- Iraj Anvar, for feedback on the Persian.
- Nader Naderpour, for feedback on the Persian.
- Peter Lamborn Wilson, for a poignant preface.
- Massoud Valipour, for the Nasta'ligh calligraphy.
- Joseph Michael, for his generosity.
- Regina Sara Ryan, the Managing Editor of Hohm Press.
- WNYC-FM, evening and night crew, for keeping me company during my many nights of preparing this book.

*also*

Pandit Pran Nath, LaMonte Young, Marian Zazeela, Philip Glass, Annemarie Schimmel, Roger Waters, Tony Zuccarello, Harsha Ram, Peter Miles, Amir Ali Vahabzadegan.

The production of this book was made possible in part through a generous grant from The Merchant & Ivory Foundation, Ltd, New York.

# CONTENTS

# RENDING THE VEIL

## *Preface*

The translator performs a sacred work. But sacrifice, making-sacred, is also a kind of killing, a violation of normal borders. Translation should perhaps be hedged about by taboos, like sacrifice, in order to counteract the impurities inherent in such violence. To tear a text from the matrix of its language and carry it across into another language has been called "betrayal." At worst, it is a kind of death, at best a death-and-resurrection. In either case, however, an act of magic has been performed— and the translator occupies a borderland, a marginal or liminal state or "midsummer night's dream" of the intellect and spirit.

This supernatural aspect of translation becomes most acute in the treatment of a sacred text—which explains why such undertakings are invariably accompanied by miracles. Hence the 72 translators of the Septuagint, working alone in separate cells, miraculously produced identical texts; and the transferal of Buddhist scriptures to China produced an entire magical epic, Wu Ch'eng-En's marvelous *Monkey*. This magic insures that the text will be re-born in its new language, that it will have a life of its own and on its own. The miraculous story is a sign that the text itself has agreed to be sacrificed and passed through the dangerous chaos between

one language and another—a sign that it will retain its "angelic" function. The "sacred" text (not only scripture but also epic, tale, poem, treatise) is not mere words on paper but a kind of living person, like the Letter in *The Hymn of the Pearl,* which is also a bird and an angel. Books have lives of their own: the Divan of Hafez is still used as an oracle, and in fairy tales the wizard's book is itself a magical force or animate talisman. The magic of the text is direct and real, not indirect and intellectual: the old Irish bards could ruin the luck of an ungenerous patron with a satire, and the Protestant Bible itself initiated the rebel mystics of the Reformation, without the mediation of Church or priest.

Without the guarantee of such magic, translation runs the danger of functioning merely as violation or theft. The modern West has "mastered" every language, and has appropriated to itself the wisdom of all ages and peoples in a kind of indiscriminate rape and pillage of imperialist colonialism. The sacred tales of a tribe, which for its people constitute the one and only storehouse of images, rituals, memories, and breakthroughs of the spirit, are now packaged for our efficient consumption along with the looted treasures of a dozen other "disappearing" cultures. We congratulate ourselves on "saving" this "precious heritage" when in fact we are simply using it as a form of psychic TV. We pay money for poems and tales as if they were commodities rather than gifts—for gifts (in all fairy tales) call for reciprocity, and we have nothing to give back.

Translation is always violent; but this orgy of appropriation is a holocaust, a death with no rebirth, no compensation, no blood money. The poet/anthropologist Nathaniel Tarn has gone so far as to propose a School of "Anti-translation," devoted to preserving the secrecy of other peoples' texts. If the findings of Edward Said are applied not only to orientalism but to all forms of cultural appropriation, then we translators must indeed either fall silent, or else quickly (under pain of transformation into swine) discover a theory of translation as tact.

Rumi's pen-name, "the Silent," may serve us as a key to our dilemma. In every other poem he commands himself to silence, and yet he continues to flow with poetry, the very archetype of the *vates,* the inspired poet-seer or bard. And Rumi himself was a translator; his great epic Mathnawi has been called "the Koran in Persian." As he extemporized his poems, Rumi would grasp a column on his porch and whirl around it, as his disciples took dictation; and this whirling-out of the text (from the liminal threshold and the world-axis) was so magical it became the ritual

of the Sufi Order founded in Rumi's name, the so-called "Whirling Dervishes." In short, we must aspire to translation as magic; only thus can we deal with the paradox of a text which is also a form of silence. Apparently it is possible to include "silence" within the text, and even within the translated text, and yet still write.

It's hard to say what this would entail in practical terms. We know what it isn't, but have trouble thinking what it might be. For example, Native American Elders have recently expressed dismay over the New Age fad for Indian religion, in which Indian tales are retailed to empty yuppies who are bored with their own lack of culture; consumers who wouldn't lift a finger on behalf of real Indians' real struggle against 500 years of unbelievably blatant cultural murder. The Elders explained that they were not demanding "Whites stay out!" since, in fact, universal siblinghood is one of the chief tenets of their belief. What disturbed them was the violation of initiatic space. In their anger the Elders hinted they might not be able to restrain the violence of certain young warriors. One envisions a kind of actual and active anti-translation squad! And yet, clearly there is value in translating Native American spirituality—there is even an urgency about it, a sense of emergency which impelled (say) Black Elk to dictate his memoirs to Neihardt. Here then we have a true Scylla and Charybdis. How is the sincere translator to navigate this abyss? For despite everything, an instinct we trust still suggests that translation is worth doing.

The imperialist and essentially Eurocentric model of world culture has already died at its center, though its tentacles still writhe and cling as if a head directed them. The appropriation of "other" cultures, and their replacement with the media of commodity and control, makes up the inane strategy of a power which is already moribund and (worse) boring. The first European scholars of sufism were literally spies, reporting on the Orders as secret societies, the poetry as rebel ideology. Missionaries—the advance-guard of colonialism—carried out the first translations. Inasmuch as remnants and writers of this school of translation still survive and even seem to prevail, it becomes our "great game" to oppose them, and to decompose their works. But we can do more than criticize. We can also propose an entirely different model of world culture—a model "with heart," as the sufis or Native American shamans would say.

Our new model favors no one central culture (or complex of cultures) of control —no Cartesian brain-in-a-jar, coldly and rationally weighing each datum for its utility in the unfolding of the Absolute State—

no categorical criteria, no "stages of development" based on the ideology of progress—no spectacular reproduction of "alien experience"—no buying and selling of secrets. Instead we propose a decentering of the map, and the replacement of the dead grid of power and interpretation by a living "net of jewels" in which each jewel reflects and contains all the others. The politically correct have propounded a degraded version of this project under the rubric of "multiculturalism." We would prefer rather to speak of creative chaos, in which each culture is valued both in itself and as a source of integrative vision, in which no transmission is privileged unless it enhances conviviality, in which tact is exercised in matters of initiatic space and everyday life, in which the economy of the commodity is replaced by the economy of the Gift. "Multiculturalism" implies that each exotic "sub" culture is being given its due, under the aegis of the one true central culture of Eurocapitalist discourse. The poet Nathaniel Mackey suggests that we use instead the term crossculturalism, which implies both center-lessness and mutual enhancement.

Now clearly translation has a role—perhaps a central role—to play in the emergence of such a non-hierarchic and infinitely variegated "world culture." Each age needs its own translations. Much of the work of the 19th and early 20th centuries already needs rewriting from a "post-imperial-ist" perspective. Our intention as translators has shifted—from appropri-ation to sharing—and with it our style and choice of texts will also shift. This is a subtle matter; any ideological preconceptions would contaminate the spontaneous flow of meaning across borders which we envision. We need theoria (vision)—but we do not need "academic standards," canons, orthodoxies, new forms of chauvinism or friendly-faced aesthetic fascism. We need values—such as conviviality—but no political agendas. Paradoxically the "Anti-translation" movement will produce even more translations. This process has already begun. The paradigm we dimly fore-see has in fact already "emerged." Its heart is alive.

The present text makes a case in point. For one thing, it is arranged as both a translation and as a reading guide. It invites participation; each reader may become a translator. Even more significant, the translator him-self is a translated person, a Persian translating Persian poetry into English—into good English—and creating a new trans-border identity for himself out of his giving and taking. He has set up a chain of reciprocity in which he mediates between Rumi and the post-imperialist English reader. This is his donation. This version of Rumi—this text you hold in your hands—

quite literally constitutes a crosscultural game for humans who like to learn by playing (i.e., "homo ludens"). If you simply want to read a book of Rumi's poems, you may enjoy Mr. Shiva's fine versions. If you want to play however, you can use his literal trots to compose your own "imitations"—or you might even learn the Persian alphabet, get a dictionary, and use the trots to work up your own genuine translations. You could collaborate with Mr. Shiva in a crosscultural transmission—a magical and friendly act that might, ever so slightly, change your life.

Up until a few years ago it was possible to complain that Maulana Jalal al-Din Rumi was still neglected in our part of the world, despite the fact that he can be compared in stature only to such Occidentals as Dante and Shakespeare. Even today we possess no complete translation of his vast Divan, and no adequate translation of his Mathnawi. Nicholson's translation of the latter is complete, but is written in the style of a trot—with the spicy passages in Latin! Arberry's slender selection of *Tales From The Mathnawi* remains the best introduction to this work, even though it omits most didactic passages from the stories it includes, and is written in rather pedestrian prose. The Mathnawi is generally accepted as the greatest work in Persian literature, not only as a complete expression of sufism but also as the literary "epic" of the Persian/Islamic world (including Turkey, India, etc.)—a book which has "everything" in it—the quintessence of an entire culture.

In the last decade or so a number of translators have mined the Divan for selections of lyrics, and although the quality of these works has varied wildly, we can hope at least that they may have created a climate in which more serious projects can be undertaken. (The present work represents a step forward in that it includes about 13 per cent of the quatrains or rubaiyyat from the Divan—about 70 per cent of these have never been translated.) If these current translations have tended to situate Rumi in a "New Age" context too shallow for his profound depth, at least they have saved him from the academics, and from ignorant prejudice against all things Islamic. Our "post-Christian" society still hates the Saracen and still launches spectacular crusades (Libya, Iraq) against Islam; the *New York Post* and the *Evening News* unconsciously re-create the slanders of Roland and the Cid. And much of the academic world still approaches Islam from the point of view of spying and appropriation, thinly veiled with "multicultural" rhetoric. In short, every little bit helps—even if the New Age Rumi is as distorted an image as the others, at least he will be read. And

very recently, a few existentially-committed (i.e. pro-sufi) scholars have
produced valuable and accessible studies of Rumi, which help to situate
the plethora of slender volumes of verse in some more accurate perspec-
tive. (See especially William C. Chittick, Anne-Marie Schimmel, and, with
reservations, the many translations of Coleman Barks.)

And what of the "real" Rumi? I doubt that any of the works avail-
able to us will convey this initiatic knowledge, unless we're willing to slog
through Nicholson's Mathnawi and virtually re-write it as we read. This
exercise might convey something of the angelic quality of the book—for
certain books are capable of an active relation with their readers, as if they
contained or, in fact, embodied the living souls of their authors. In this
sense, books initiate. (Some sufi orders teach methods of initiation via
dreams experienced at the tombs of certain saints, since the tomb is believed
to contain an aspect of the living soul. Books are tombstones as well—but
magic tombstones.)

Rumi was born in an interesting place. Balkh is now a tiny village
inside vast ruined walls, in northern Afghanistan. Long ago, Mahayana
Buddhism first arose in this very region—and there may be vague traces
of Mahayana ideas in Rumi: his poetic belief in metempsychosis for exam-
ple, or his adamant universalism—both of which have at times given
offense to orthodox Islam. Central Asian sufism, which owes more to
Buddhism, shamanism, and perhaps Manicheanism, than does Western
sufism, may have played a larger role in Rumi's esoteric education than
generally recognized.

Born 1207 C.E., Rumi left Balkh at an early age as his family fled
before the Mongols. His father Baha' al-Din Walad was himself a great sufi
shaykh, and Rumi's first murshid or initiator. Rumi may have met Ibn
'Arabi, and was certainly a close friend of Ibn 'Arabi's famous student Sadr
al-Din Qunawi (i.e., "of Konya," the Turkish city where Rumi lived and
died). But none of these influences created Rumi the poet.

Rumi burst into song, he tells us, because he loved, and lost, a
perfect friend. Like most medieval moslems, Rumi lived in an "ambisexual"
world, where men were expected to marry, but also expected to love boys,
and/or to engage in intense friendships with other men. No modern word,
such as "homosexual," can be accurately applied to this social complex.
We presume (because Rumi gives us no reason not to presume) that this
love-affair with Shams al-Din Tabrizi was entirely chaste. Nevertheless, it
was a cause of scandal. According to the most widely accepted story, Rumi's

own disciples murdered Shams ("the Sun") and hid his body in a well—
a clear evocation of Neolithic Near-Eastern myth, and yet also (perhaps)
an historical fact. Rumi was a "published" author and master of an Order
long before he met Shams, a mere itinerant candy-seller and wild (unaffil-
iated) dervish. Rumi and Shams went off wandering together, and left no
forwarding address. Shams was clearly not Rumi's "master," nor was Rumi
the murshid of Shams. Their relation could not and cannot be defined in
terms of organizational sufism. The disciples certainly had a motive.

Who was Shams al-Din Muhammad of Tabriz? Legend associates
him with the last Grand Master of Alamut, the Imam of the Ismailis
("Assassins"), who fled the Mongols and is said to have disappeared in
Tabriz, and who was named Shams al-Din Muhammad. Dating alone
makes this story impossible (Rumi's Shams probably died in 1247, when
Shams the Ismaili was still an infant)—but the legend itself is meaning-
ful. An air of heterodoxy attaches itself to the image of Shams of Tabriz.
As a "Blameworthy" sufi he may have used a reputation for heresy as a
mask for his true spiritual practice, which remained orthodox. This, at any
rate, is the orthodox explanation. The whole question is exceedingly
delicate. Mainstream orthodox sufism claims Rumi as its own, and has
therefore found satisfactory answers to all questions. But heterodox sufism
also claims Rumi. So does Shiism. So does Ismailism. One might say that
the "real" Rumi left no forwarding address; as for Shams, he disappeared
without trace.

My former teacher, Seyyid Hossein Nasr, used to say that Shams
was like the Sun, and Rumi was like the sea; as the Sun passed quickly
overhead, its gravitational force drew great waves of love from the sea,
which cast up pearls of poetry upon the shore. A nice metaphor, but one
which fails to do justice to the companionship of Shams and Rumi. True,
one was lover and the other beloved. And Shams was Rumi's Muse, or
Angel. (A charming story claims that Shams persuaded Rumi to throw
away all the books he'd written—into a well—whereupon they rose again,
pages dry and blank, ready to receive Rumi's true masterpieces.) All this
is perhaps true, but not the whole story, and perhaps not the most inter-
esting part of the story from a psychological point of view.

Above all, I think, Shams and Rumi were friends.

The young Rumi was bookish and precocious—his own father
taught him and brought him up to be a sufi master—and it's easy to imagine
that although everyone admired him, no one knew him or loved him. The

sheer ecstatic release of spiritual friendship can be felt on every page of that most delightful of hagiographies, Aflaki's *Life of Rumi* (the *Menaqibu'l-'arifin*). Late one night, for example, as Shams and Rumi sat meditating together on a roof somewhere, they decided that everyone in town should share the marvels they were experiencing, and so cooked up a burst of thunder from a clear starry sky: two saints, prankish as boys with fire-crackers.

After the murder or disappearance of Shams, Rumi experienced yet another psychic upheaval. He became Shams. His Divan is not dedicated to Shams—it IS the Divan of Shams al-Din Tabrizi, and it is written in his voice.

Now, the pious moslem will have an explanation for this—the psychiatrist will have an explanation for this—the sufi scholar will speak of waves and pearls—but no analysis or metaphor I've ever heard can do justice to the sheer strangeness and intensity of this identification. Perhaps the image of alchemical marriage might elucidate some aspect of this mystery. Sun and Moon unite to produce the Philosopher's Stone, which turns everything to gold just as Rumi/Shams turned everything (love and loss) into poetry. Even this symbolism however seems inadequate, overly pedantic and obfuscatory, in face of the blazing light of the Divan.

And of that light, you are about to receive a beam. Be prepared for the book-as-angel.

*Peter Lamborn Wilson*
*New York, July 4, 1993*

# TRANSLATOR'S NOTE

These words are a drop,
From love's infinite ocean.
To the world,
thirst-quenching nectar.
To the soul,
everlasting life.
-*Rumi*

Only Rumi can praise Rumi since he alone has a complete under-standing of his own art. For the past 700 years, none of the innumerable treatises, lectures, and books on the life and work of Rumi have been able to satisfy the curious mind of a Rumi enthusiast. No study has been able to match the magnitude of his poetry. Over a period of 25 years, Rumi recited approximately 70,000 verses of divine love poetry.

In the East, Rumi has been called *Khodavandegar* (lord), Moulana (our master), *Hazrat* (saint), and in the West he has been dubbed "the greatest mystical poet of any age" (R.A. Nicholson), "He can be compared in stature only to such occidentals as Dante and Shakespeare" (Peter Lamborn Wilson).

The best way of learning more about the poet is through his poetry, but no translation can do justice to Rumi's immaculate style. Each poem is a most passionate and beautiful package that contains purity of form, meter and expression, fluidity of verse, originality of style, and profoundity

of thought. There is an inherent sweetness to each verse. One who understands Persian listens to Rumi not only for the exquisite words or the profound message. Rather, it is sound or the rhythm of Rumi's verses that captures one's attention—the way a certain word follows another creating a fantastic chemistry of sound, as in poems 956 UT and 1540 UT. How much of this package can be transferred into another language or culture safely? Is it possible to enhance the experience of the reader?

In 1989, with the gifted American poet Jonathan Star, I began a collaboration which eventually led to the publication of our book, *A Garden Beyond Paradise, The Mystical Poetry of Rumi* (Bantam, 1992). I began translating Rumi mainly due to the intimacy I felt with him and his powerful, moving poems, and also because of the void I found in the field of Persian poetry translations. Being familiar with the grand beauty of the Persian verse, and aware of the large quantity of Rumi poetry being published by various English-speaking authors, I could not find a single translation or rendition that had all the right elements which exist in a Rumi poem. Except for a few interpreters (i.e., Dr. A. Schimmel, Mr. P.L. Wilson, Mr. D. Leibert), the translations were either painfully literal without any concern for the poetic quality, or the renditions were too personalized, lacking respect for the spirit of Rumi. For me, both approaches were nearly impossible to read. For example, I remember being excited about obtaining a translation of Attar's *Conference Of The Birds*. I planned to read the book, in its entirety, the evening of the day I got it. However, as much as I tried, I could not finish more than a page and a half. That book was not a translation of Attar, it was a medium for the translator trying to be Attar. Respect for the spirit of the original poet had been discarded. In *A Garden Beyond Paradise*, therefore, Jonathan Star and I tried to get out of the way of the poems. From the feedback we received, our objective was met to a certain degree. Marian Zazeela, a noted calligrapher, light artist, and long-time student of mysticism, affirmed: "Until I read *A Garden Beyond Paradise* I had difficulty reading and understanding translations of Sufi poetry and I thought that it was my own fault. With this book I was able to read it from cover to cover, and truly grasp the feeling of the poetry."

With *Rending The Veil*, I feel that the lovers of Rumi are ready to move on to the next plateau—Rumi in Persian. Nothing compares to reciting his poems in their original verse. They are complete. Here the Western reader will be able to know how Rumi actually recited these poems. To provide this possibility, I decided to employ a style of translation that is

common in Sanskrit. In this current format the reader has access to the Persian through an easy-to-read transliteration, can know the meaning of every word (with minor commentary) through verbatim translation, and can understand the message of the poem through a semi-poetic, four-line translation. The Persian script is also provided. In my task as translator I have tried to become as transparent as possible, attempting to grant the readers of Rumi unadulterated access to his quatrains. Here they can transcend the interpreters and find Rumi's voice for themselves. (It can perhaps be called an interactive approach to Rumi.) That is how I think any poet would want his or her work to be offered to the people of another culture.

Knowing Rumi and translating his poetry has been an experience of homecoming for me. On many occasions, while focusing on his words, I felt him reaching out of the pages of the book and embracing me. In truth, this is the experience that this book tries to share with the Western reader. It is the Persian of Rumi that is all encompassing. It is the Persian of Rumi that heals spiritual wounds. It is the Persian of Rumi that initiates the seeker into the world of the unknown. It is the Persian of Rumi that transforms the character and uplifts the soul, and the Western reader should not be kept away from it.

Moreover, *Rending The Veil* has been an opportunity to add to the pool of translated quatrains of Rumi. About seventy percent of these poems have not been available to the English-speaking reader before. I chose Rumi's quatrains because they lend themselves to this method of translation easier. As for the particular quatrains in this book—after multiple readings of all of the 2,000 available quatrains of Rumi presented in the *Divan-e Shams-e Tabrizi* (Rumi's collection of passionate poems), I selected 500 that seemed to me to be unique, each incorporating an original image (since many of Rumi's quatrains express similar imagery). Of the 500, I chose 252 to be presented here.

Two editions of the Divan were used as sources for this book: the single-volume, complete collection of the Divan, printed by the Amir Kabir Press, Iran, (1988), and Volume Eight, *The Quatrains from the Divan,* printed by the University of Tehran, Iran, (1963), both edited by the late Mr. Badiuzzaman Furuzanfar. (Rumi did not use the quatrain style in the Massnavi, his poetic collection of guiding-words for the students of mysticism.) In *Rending The Veil,* every quatrain carries its original number from the corresponding source book, followed by the letters AK for the Amir

Kabir edition and UT for the University of Tehran edition (i.e., 171 AK, 764 UT). Poems are presented in numerical order.

Although Mr. Furuzanfar's editions are the most trusted, they are not completely error-free. Consulting with Dr. Iraj Anvar (professor of Persian Literature at New York University) on a few of the quatrains that presented some difficulty, we found that three had misprints of no more than one word per poem. Quatrains 764 UT, 861 AK, and 1515 UT have since been corrected in the Persian script used in this book.

Moreover, all poems presented here do have four lines, yet they are not all ruba'iyat (true quatrains). According to Mr. Nader Naderpour, renowned Iranian poet, a quatrain is a ruba'i when the meter matches this formula: Laa Hollo Valaa Ghovate Ellaa Bellaa, as in poem 264 UT. Hence, to be accurate, this book is a compliation of ruba'iyat, dobeitys (couplets) and four-line ghazal (love poem) fragments of Rumi, derived from the quatrains section of the Divan.

Finally, I would like to address the issue of drunkenness, the question most commonly asked by the audiences at my readings of Rumi's poetry. People want to know what percentage of this is literal and what portion is a metaphor for something higher. *Rending The Veil* includes eight quatrains that specifically address this issue. Clearly this subject was a controversial issue even at the time of Rumi. Since there is such frequent mention of wine, ecstasy, and the Saaqhi (cupbearer). These poems are: 82 UT, 171 AK, 344 AK, 684 AK, 988 AK, 1019 UT, 1322 UT, and 1652 AK. Judging from these and other Rumi poems it is clear to me that being drunk means being taken away or enraptured by a divinely-induced state of ecstasy. And Saaghi, simply, is the term given to the moment this feeling is bestowed upon an individual. May Rumi's original poems grant you a taste of that state.

*Shahram T. Shiva*
*September 23, 1994*
*New York City*

# KEY TO THE TRANSLITERATIONS

Unlike the languages of the neighboring countries of Iran, Persian (Farsi) is easy to pronounce. There are no complicated H sounds or multiple sounds for the letter S. Persian does not differentiate between male and female; it is not gender specific. They best way of reading the transliterations is by pronouncing the words as written, syllable by syllable. The format of transliteration used here is the most simple available. Similar to Italian, simply by reading the words phonetically, and keeping in mind a few rules about the style of this transliteration, the reader should be able to read Rumi's quatrains with much ease without any knowledge of Asian languages.

| VOWEL | SOUND |
|-------|-------|
| a | cat |
| aa | caught |
| e | get |
| ee | deed |
| i | did |
| o | go |
| oo | good |
| gh | rue, R in French |
| kh | Bach, ch in German |
| zh | je, J in French |
| ' | short pause |

### ALSO

| | |
|---|---|
| to | pronounced toe |
| ( ) | explanation, commentary |
| [ ] | addition |
| underline | marks syllables in long words |
| ...-e (Shams-e Tabriz) | means ...of, (Shams of Tabriz) |
| ...-o (Shams-o Rumi) | means ...and, (Shams and Rumi) |
| | |
| UT | University of Tehran Press |
| AK | Amir Kabir Press |

# RENDING THE VEIL

2 AK

Aan sham`e rokh-e to, la<u>ga</u>nee neest biyaa
Vaan Naghsh-e to, az aab-e-manee neest biyaa
Dar khashm makon to, kheesh<u>tan</u>raa penhaan
Kaan hosn-e to, penhaan shodanee-neest biyaa

*that | candle of | face of | you | [created in the] pelvis | it is not | you come*
*and that image of | you | of | semen | it is not | you come*
*in the | wrath/anger | don't do | you | yourself | hide*
*because that | virtue/goodness of | you | hidden | it is not possible | you come*

The glow of your face was not created in your mother's womb. Come.
The image of you was not produced by your father's semen. Come.
Don't hide behind this wrath
Your truth, your virtue, can not be disguised. Come.

3 AK

آنکس که بسته است او خواب مرا

تر میخواهـد زاشک محراب مرا

خاموش مراگرفت و در آب افکند

آبی که حلاوتے دهد آب مرا

◈

Aan kas ke be<u>bas</u>te-ast, oo khaab-e maraa
Tar mi<u>khaa</u>had ze ashk, mehraab-e maraa
Khaamoosh maraa gereft-o, dar aab afkand
Aabee ke, halaa<u>va</u>tee dahad aab-e maraa

◈

*that | person | who | has closed/taken away | he | sleep of | mine*
*wet | he wants | of | tear drops | altar of | mine*
*in silence | me | he grabbed and | in | water | he threw*
*the water | that | sweetness | it gives | water of | mine*

◈

The thief of my sleep
Is wishing my altar wet with my tears.
He grabbed me in silence and threw me in water
A water with a sweetness that sweetens my own.

9 AK

<div dir="rtl">
از باده لعــــل ناب شد گوهــــر ما

آمد به فغـــان زدست ما ساغــــر ما
</div>

<div dir="rtl">
از بسکه همی خوریم می بر سر می

ما در سر می شدیم و می در سر ما
</div>

◉

Az baadeye la'el, naab shod gohar-e maa
Aamad befaghaan, ze dast-e maa saaghar-e maa
Az-baske hamee-khoreem, mei bar sar-e mei
Maa dar sar-e mei shodeem-o, mei dar sar-e maa

◉

*of | wine of | ruby (like) | pure | became | jewel/essence of | mine/ours*
*it came (started) | to wail/groan | of | hands of (because of) | me/us | the cup of | mine/ours*
*because | continuously I/we drink | wine | on | top of | wine (one after another)*
*I/we | in the | head of | wine | became and | wine | in the | head of | mine/ours*

◉

My jewel turns pure from the Beloved's ruby wine.
My cup starts wailing, groaning because of me.
I have been drinking cup after cup after cup of this wine
I have become the wine and the wine has become me.

11 AK

هر ذکر بسی نور فزاید مه را

در راه حقیقت آورد گمره را

هر صبح و نماز شام ورد خود ساز

این گفتن لا اله الا الله را

Az zek'r basee noor, fazaayad mah-raa
Dar raah-e hagheeghat, aavarad gomrah-raa
Har sobh-o namaaz-e-shaam, verd-e khod saaz
Een goftan-e Laaelaahe Ellal'laah-raa

*of | repetition [of the name of God] | verily/often | light | to increase | the moon
in the | path of | truth | it brings [back] | the lost ones
every | morning and | prayer of dusk | formula/prayer of | yourself | make
this | saying of | there is no God but Allah*

The repetition of God's name brings light to the full moon.
This repetition brings back the lost ones to the path of truth.
Make this your word, for every morning and evening prayer
The saying of "There is no God but Allah."

15 UT

یکچند بتقلید گزیدم خود را ؛

نادیده همی نام شنیدم خود را

درخود بودم، زان نسزیدم خود را

ازخود چو برون شدم، بدیدم خود را

Yekchand be<u>tagh</u>leed, gozeedam khod-raa
Naadideh haminaam, sheneedam khod-raa
Dar khod boodam, zaan nase<u>zee</u>dam khod-raa
Az khod cho beroon shodam, bedeedam khod-raa

*for a while | imitating [others] | I preferred (out of pride) | myself*
*not seeing | this name | I heard (I thought of) | my self*
*in | myself | I was | [because] of that | I didn't deserve | myself*
*of | myself | when | out | I went | I saw | myself*

For a while, imitating others, I was proud of myself.
Innocent, I thought of myself as only a name.
When I was in my self I did not realize my true nature.
When I went beyond my self, then I realized my self.

20 AK

<div dir="rtl">

ای خواجه بخواب ور نبینی مارا

تا سال دگر دگر نبینی مارا

ای شب هر دم که جانب ما نگری

بی روشنی سحر نبینی مارا

</div>

◈

Ey-khaaje, be<u>kh</u>aab var nabeeni maa-raa
Taa saal-e degar, degar nabeeni maa-raa
Ey-shab hardam ke, jaaneb-e maa negaree
Bee rosha<u>ni</u>ye sahar, nabeeni maa-raa

◈

*O wise one | sleep | although | you don't see | me*
*until | year of | next | again | you won't see | me*
*O night | every breath/moment | that | toward | me | you look*
*without | the brightness of | dawn | you won't see | me*

◈

Sleep, O wise one, even though you don't see me
And though for another year you won't see me.
O night, you look toward me every moment
But without the light of dawn, you won't see me.

32 UT

دَرجانِ توجانیست، بِجوآن جانرا

دَرکوهِ تَنت دُرّی بِجوآن کانرا

صوفیِ رونده ! گر تو آن میجویی

بیرون تو مجو، زخود بجو تو آنرا

◈

Dar jaan-e to jaaneest, bejoo aan jaan-raa
Dar kooh-e tanat doree, bejoo aan kaan-raa
Soofiye ravandeh, gar to aan mijooyee
Beeroon to majoo, ze khod bejoo to aan-raa

◈

*in the | soul of | you | there is a life force | seek | that | life*
*in the | mountain of | your body | a gem | seek | that | mine*
*sufi the | wayfarer | if | you | that | are seeking*
*out side | you | don't seek | in | yourself | seek | you | that*

◈

There is a life-force within your soul, seek that life.
There is a gem in the mountain of your body, seek that mine.
O traveler, if you are in search of That
Don't look outside, look inside yourself and seek That.

33 AK

پرورد بناز و نعمت آندوست مرا

بردوخت مرقع از رگ و پوست مرا

تن خرقه و اندر او دل ماصوفی

عالم همه خانقاه و شیخ اوست مرا

◈

Parvard benaaz-o ne'mat, aandoost ma-raa
Bardookht morgha, az rag-o poost ma-raa
Tan kherghe-o, andar oo del-e maa soofee
Aalam hame khaanghaah-o, sheikh oost ma-raa

◈

*he fostered/cherished | with comfort/praise and | riches | that friend/Beloved | to me*
*he sewed/tailored | a garment | of | veins and | skin | for me*
*the body | a robe and | in | him | heart of | mine | a sufi*
*the world | all | a Khaneghah/monastery and | master | he is | to me*

◈

The Beloved weaned me with praise and riches.
He tailored a sheath of veins and skin for my soul.
This body is His robe, and I, a Sufi, reside in His heart.
All the world a Khaneghah, and He is its master.

60 AK

گر بوی نمی بری در این کوی میا

ور جامه نمی کنی در این جوی میا

آنسوی که سوی ها از آنسوی آمد

می باش همان سوی و بدین سوی میا

❖

Gar booy nemibaree, dar een kooy mayaa
Var jaame nemikanee, dar een jooy mayaa
Aansooy ke sooy<u>haa</u>, az aan sooy aayad
Mibaash haman<u>sooy</u>-o, bedeen sooy mayaa

❖

*if | smell (understand) | you can't | in | this | alley | don't come*
*and if | clothes | you don't tear off | in | this | stream | don't come*
*that direction | which | directions | of | that | direction | come (source of*
*directions/center of compass)*
*stay | in that direction/side and | to this | direction/side | don't come*

❖

If you can't grasp us, to this alley do not come.
If you can't strip your clothes, to this stream do not come.
This is the center of the compass, no place for cowards
Stay on your side, to this side do not come.

62 AK

گر در طلب خودی ز خود بیرون آ

جو را بگذار و جانب جیحون آ

چون گاو چه می‌کشی تو بار گردون

چرخی بزن و بر سر این گردون آ

◈

Gar dar talab-e khodi, ze khod biroon'aa
Joo-raa bogzaar-o, jaaneb-e jeyhoon'aa
Chon gaav che meekeshee, to baar gardoon
Charkhee bezan-o, bar sar-e een gardoon'aa

◈

*if | in the | desire of | yourself you are | of | yourself | come out*
*the stream | you pass and | toward the | Oxus River come*
*like | an ox | why | you pull | you | the load | in circles*
*turn | you make and | in the | head/top of | this | world/wheel of cosmos come*

◈

If you desire your own divinity, come out of yourself
Pass over that stream and come toward the Oxus River.
Like a bull treading in circles you pull the load of ages
Turn around. Come to the top of the wheel of creation.

64 UT

ای آنک چو آفتاب فردست بیا

بی روی تو باغ و برگ زردست بیا

عالم بی تو غبار و گردست بیا

این مجلس و عیش بی تو سردست بیا

❖

Ey aanke cho aafetaab fardast, biyaa
Bee rooy-e to, baagh-o barg zardast, biyaa
Aalam beeto ghobaar-o gardast, biyaa
Een majles-o eysh, beeto sardast biyaa

❖

*O | you that | like | the sun | singular you are | come*
*without | face of | you | garden and | leaf | are yellow | come*
*the universe | without you | dust and | powder it is | come*
*this | gathering and | pleasure | without you | is cold | come*

❖

O you, alone in the sky like the Sun. Come.
Without your face the garden and the leaves are all yellow. Come.
Without you, the universe is dust and powder. Come.
Without you, this drunken gathering is cold. Come.

67 AK

Gah meegoftam ke, man ameeram khod-raa
Gah naale konaan ke, man aseeram khod-raa
Aan raft-o az een-pas, napazeeram khod-raa
begraftam een ke man, nageeram khod-raa

at times | I would say | that | I | am the king | of myself
at times | groaning | I did | that | I | am a prisoner | of myself
that | is gone and | from | now on | I won't accept | myself
I hold (believe) | this | that | I | won't hold (to show sign of pride) | myself

At times I have said I am my own king
At times I have said I am my own slave
That time is gone, for now I won't accept myself,
I hold this true, I won't boast of myself.

72 AK

منصور بدان خواجه که در راه خدا

ازپنبهٔ تن جامه جان کرد جدا

منصور کجا گفت انا الحق می گفت

منصور کجا بود خدا بود خدا

◈

Mansoor, bod-aan khaaje, ke dar raahe khodaa
Az pan<u>be</u>ye tan jaame'e jaan, kard jodaa
Mansoor kojaa goft? Anal<u>hagh</u> meegoft
Mansoor kojaa bood? Khodaa bood khodaa

◈

*Mansoor (Hallaaj) | was this | wise man | whom | on the | path of | God*
*of | fibre/cotton thread of | body | garment of | the soul | he made | separate*
*Mansoor | where/what | he said | I am the truth | he said*
*Mansoor | where/who | he was | God | he was | God*

◈

Mansur was such a master, that on the path of God
He split each thread from the fabric of his soul.
What did Mansoor proclaim? "I am the Truth."
Who was Mansoor? He was God, he was God.

82 UT

<div dir="rtl">

حاجت نبود مستی ما را شراب

یا مجلس ما را طرب از چنگ و رباب

بی ساقی و بی شاهد و بی مطرب و می

شوریده و مستیم چو مستان خراب

</div>

---

Haajat nabovad, mastiye maa-raa besharaab
Yaa majles-e maa-raa, tarab az chang-o robaab
Bee saaghiy-o, bee shaahed-o, bee motreb-o mei
Shoree<u>deh</u>-o masteem, cho mastaan-e kharaab

---

*necessary | it is not | drunkenness of | us | to [drinking] wine*
*nor | the gathering of | ours | festive | of | harp and | rubaab*
*without | the cup-bearer and | without | witness/companion and | without | musicians and | wine*
*dishevelled and | drunk we are | like | drunkards of | wasted (totally drunk)*

---

Our drunkenness does not come from drinking wine.
Our gathering, so festive, it is not from harp or rubaab.
Without the cupbearer, without a companion, without musicians or wine
We are dishevelled and dizzy like wasted drunkards.

109 UT

ای همچو خر و گاو ، که و جو طلبت

تا چند کند سایس گردون ادبت

لب چند دراز میکنی سوی لبش

هرگنده دهان چشیده از طعم لبت

Ey hamcho khar-o gaav, kah-o jo talabat
Taachand konad, saayes-e gardoon adabat?
Lab chand deraaz mikonee, sooy-e labash?
Har gandeh dahaan, chesheed az ta'm-e labat

*O | like | donkey and | cow | hay and | barley | you deserve*
*how long | should the | politician of | the turning [world] | discipline you*
*lips | how long | stick out | you do | toward | his lips (anyone's lips)*
*every | stinking | mouth (breath) | has tasted | of | the flavor | of your lips*

You deserve hay like donkeys and cows.
How long should the ruler of the world keep you quiet?
How long will you stick your tongue out toward their lips?
Every stinking mouth knows the flavor of your lips.

130 UT

امروز چه روزاست که خورشید دوتاست

امروز ز روزها برونست وجداست

از چرخ به خاکیان نثارست و صداست

کی دل شدگان، مژده، که این روز شماست

◈

Emrooz che roozast, ke khorsheed dotaast
Emrooz ze rooz<u>haa</u>, beroo<u>nast</u>-o jodaast
Az charkh, bekhaakian nesaa<u>rast</u>-o sedaast
Kei delshodegaan, mozhdeh, ke een rooz-e shomaast

◈

*today | what [kind of] | day it is | that | the sun | is two*
*today | of | days | is outside (different) and | it is separate*
*of | the wheel | to the earthlings | is a call to a wedding and | a sound*
*that O | you who have become one with your hearts | good news | that | this | day*
*| is for you*

◈

What sort of day is today, there are two suns in the sky.
Today is different from any other day.
There is a call to a wedding from the heavens,
To the people of the heart saying, "Good news, this is your day, today."

130 AK

آندم که مرا بگرد تو دوراست

ساقی و شراب و قدح و دواست

وآندم که ترا تجلی احساست

جان در حیرت چو موسی عمراست

❖

Aandam ke maraa, begard-e to doraanast
Saaghiy-o sharaab-o, ghadah-o doraanast
Vaandam ke to-raa, tajali'e eh<u>saa</u>nast
Jaan dar heirat, cho moosaa'e emraanast

❖

*that moment/breath | which | to me (I) | around | you | it is (am) turning*
*the cup-bearer and | wine and | cup and | a gathering it is*
*and that moment/breath | which | to you | the shining through of | goodness it is*
*the soul | in | amazement | like | Moses [son] of | Emran it is*

❖

The moment that I turn around you
Is the gathering of Saaghi, wine and cup.
The moment you see the magnificent shine of grace
Your soul, stunned and amazed, is like Moses son of Emran.

171 AK

امشب منم و طواف کاشانۀ دوست

میگردم تا به صبح در خانۀ دوست

زیرا که بهر صبوح موسوم شده است

کاین کاسۀ سر بدست پیمانۀ دوست

Emshab manam-o, tavaaf-e kaa<u>shaa</u>neye doost
Meegardam taa besob'h, dar khaaneye doost
Zeeraa-ke behar sabooh, mosoom shodeh-aast
Ke'een kaaseye sar bedast, pey<u>maa</u>neye doost

tonight | I am and | the circumambulation of | the house of | the Beloved
I turn | until | morning | in the | house of | the Beloved
because | in every | morning draft-drink | named | he has been
that this | skull of | the head | in our hands | is the cup of | the Beloved

Tonight I am spinning around the house of the Beloved.
I'll turn and turn till dawn, around His house.
Every savoring drink has been named after Him
This skull in my hands is the Beloved's cup.

175 AK

انصاف بده که عشق نیکوکار است
زانست خلل که طبع بدکردار است

توشهوت خویش را القب عشق نهی
از شهوت تا به عشق ره بسیار است

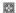

Ensaaf bedeh, ke eshgh neekookaar-ast
Zaanast khalal, ke tab'e bad kerdaar-ast
To Shahvat-e kheesh-raa, la_ghab_-e eshgh nahee
Az shahvat, taa be'eshgh, rah besiyaar-ast

*justice | you give | because | love | is a good deed*
*of that is | harm | because | the nature of | bad | disposition it is*
*you | lust of | yourself | title of | love | you give*
*of | lust | to | love | distance | great it is*

Have justice. To Love is a virtuous act
And harm is to the one who is of a harmful nature.
What you call love is only lust
Between lust and love there is a great distance.

185 AK

<div dir="rtl">

ای جان زدل تو بردل من راهست

ورجستن آن راه دلم آگاه است

زیرا دل من چو آب صافی و خوش است

آب صافی آینه دار ماه است

</div>

---

Eyjaan ze del-e to, bardel-e man raah-ast
Vaz jostan-e aan raah, delam aagaah-ast
Zeeraa dele-man cho aab, saafee-o khoshast
Aab-e saafee, aayenedaar-e maah-ast

---

*O soul | of | heart of | you | to heart of | mine | there is a connection*
*and of | finding | that | path | my heart | aware it is*
*because | my heart | like | water | is pure and | is pleasant*
*water | [that is] pure | the mirror holder of | the moon it is*

---

O my soul, there is a link between your heart and mine.
And my heart is looking for that path.
My heart is clear and pure like water
And pure water is a perfect mirror for moonlight.

211 UT

جانا غم تو هر چه گویی ، بتر ست

رنج دل و تاب تن و سوز جگر ست

از هر چه خورند کم شود ، جز غم تو

تا بیشتر ش همی خورم ، بیشتر ست

Jaanaa gham-e to ze harche gooyee, batar-ast
Ranj-e delo, taab-e tano, sooz-e jegar-ast
Az harche khorand kam shavad, joz gham-e to
Taa bee<u>sht</u>arash hamee-khoram, bee<u>sht</u>ar-ast

*O [supreme] soul | sorrow of | you | of | anything | you say | worse it is*
*torture of | heart and | twisting of | the body and | burning of | the liver/guts it is*
*of | anything | they eat | less | it becomes | except | sorrow of | you*
*when | the more of it | I eat | the more it is*

O supreme soul, your sorrow is worse than anything.
It is torture of the heart and body.
Everything people eat becomes less except your sorrow
The more I eat, the more it becomes.

223 UT

هر چند که بار آن شترها شکرست

آن اشتر مست چشم او، خود دگرست

چشمش مستست و او ز چشمش بترست

او از مستی ز چشم خود بی خبرست

Harchand-ke, baar-e aan shotorhaa shekar-ast
Aan ashtar-e mast-e cheshm-e oo, khod degar-ast
Cheshmash mas<u>t</u>ast-o, oo ze cheshmash ba<u>tt</u>ar-ast
Oo az mastee, ze cheshm-e khod bikha<u>b</u>ar-ast

*although | the load of | those | camels | is sugar*
*that | camel of | drunk of | eyes of | him | itself | is something else*
*his eyes | are drunk and | him | of | his eyes | is worse*
*he | of | drunkenness | of | eyes of | himself | is not aware*

Although those camels are carrying a load of sugar
The drunken camel of his eyes is very different:
His eyes are glazed and he is even drunker himself,
So drunk, he is unaware of his own eyes.

ما عاشق عشقیم و مسلمان دگرست

ما مور ضعیفیم و سلیمان دگرست

از ما رخ زرد و جگر پاره طلب

بازارچه قصب فروشان دگرست

Maa aashegh-e esh<u>gh</u>eem-o, mosalmaan degar-ast
Maa moor-e zaee<u>f</u>im-o, soleimaan degar-ast
Az maa rokh-e zard-o, jegar-e paareh talab
Baazaar<u>ch</u>eye, ghasab forooshaan degar-ast

*we | are the lovers of | love and | Moslems | are something else*
*we | ant of | weak are and | Solomon | is someone else*
*of | us | face of | sallow/pale and | guts of | torn | demand*
*the bazaar of | linen | merchants | is somewhere else*

We are the lovers of love, and Moslems are different.
We are weak as an ant, and Solomon is different.
Ask us for an ashen face and torn guts
The bazaar of linen sellers is different.

232 AK

بـاشـب مـيگو کـه روز مـارا شـب نيست

در مذهب عشق وعشق را مذهب نيست

عشق آن بهريست کش کران ولب نيست

بس غـرقـه شـوند و نالـه و يارب نيست

Baa shab meegoo, ke rooz-e maaraa shab neest
Dar maz'hab eshgh, va eshgh-raa maz'hab neest
Eshgh aan bahreest, kash karaan-o lab neest
Bas ghargh-shavand-o, naale-o yaarab neest

*with | night | don't talk | because | day of | ours | night | it has not*
*in | religion | love | and | love | religion | it has not*
*love | that | ocean is | which | borders and | shores | it has not*
*many | get drowned and | cry/groaning and | [saying] O God | there is not*

Don't speak of the night for our days have no night.
In every religion there is love, but love has no religion.
Love is an ocean, without borders and shores
Where many drown, yet groans of regret or a calling to God is not heard.

245 UT

گویند که : عشق ، عقل آمیز خوشت

در هر صفتی که هست ، پرهیز خوشت

آری سخنت چون زر سرخست ولیک

جان نیز فدای شمس تبریز خوشت

◈

Goyand ke, "Eshgh, agh'l aameez khoshast
Dar har sefatee ke hast, parheez khoshast"
Aaree sokhanat chon zar sorkhast, valeek
Jaan neez fadaaye, shamse tabreez khoshast

◈

*they say | that | love | intellect | mixed | is pleasant/better*
*in | every | faith | that | one is | discrimination | is pleasant/better*
*yes | your words | like | gold | it is red (shines) | yet*
*life | also | offered to | Shams-e Tabriz | is pleasant/better*

◈

They say, "Love mixed with intellect is better
In every faith, discrimination is better."
Yes, your words shine like gold, yet
My life, offered to Shams-e Tabriz, is better.

245 AK

بر من در وصل بسته می دارد دوست

دل را به عنا شکسته می دارد دوست

زین پس من و دلشکستگی بر در او

چون دوست دل شکسته می دارد دوست

❖

Bar man dar-e vasl, baste midaarad doost
Delraa be'anaa, she*kas*te midaarad doost
Zeen-pas, man-o del*shekas*tegee bar dar-e oo
Chon doost del-e-shekaste midaarad doost

❖

*to | me | the door of | union | closed | he does | the Beloved*
*the heart | with pain/suffering | broken | he does | the Beloved*
*from now on | I and | broken-heartedness | at | the door of | him*
*because | the Beloved | broken heart | he does | prefer*

❖

The Beloved shuts the gate of union, and blocks my way.
The Beloved breaks my heart with pains and sorrow.
From now on, my broken heart and I will wait at the gate.
For He prefers those with a broken heart.

255 AK

بیرون ز تن و جان و روان درویش است

برتر ز زمین و آسمان درویش است

مقصود خدا نبود بس خلق جهان

مقصود خدا از این جهان درویش است

---

Biroon ze tan-o jaan-o ravaan, darveesh ast
Bartar ze zameen-o aase<u>maan</u>, darveesh ast
Maghsood-e khodaa, nabood bas, khalgh-e jahaan
Maghsood-e khodaa, az een jahaan, darveesh ast

---

*out side | of | body and | life and | soul | darvish | it is*
*greater | than | earth and | the sky | darvish | it is*
*the purpose of | God | it was not | only | the creation of | the universe*
*the purpose of | God | of | this | universe | darvish | it is*

---

Free from life, body, and soul, is a darvish.
Greater than Earth and Sky, is a darvish.
God's only intent was not the creation of the universe
God's intention of this universe was to create a darvish.

264 UT

<div dir="rtl">

ناگه ز درم در آمد آن دلبر مست

جام می لعل ، نوش کرده بنشست

از دیدن و از گرفتن زلف چو شست

رویم همه چشم گشت ، و چشمم همه دست

</div>

Naagah zedaram daraamad, aan delbar-e mast
Jaam-e mey-e la'l, noosh kardeh, beneshast
Az deedan-o, az gere*tane*, zolf-e cho shast
Rooyam hame cheshm gasht-o, chesh*mam* hame dast

*suddenly | of my door (my being) | came out | that | sweetheart of | drunk*
*cup of | wine of | ruby | drank | she did | and sat*
*of | seeing and | of | holding of | hair | like | net*
*my face | all | eyes | became and | my eyes | all | hands*

Suddenly the drunken sweetheart appeared out of my door.
She drank a cup of ruby wine and sat by my side.
Seeing and holding the lockets of her hair
My face became all eyes, and my eyes all hands.

265 UT

هر روز بنو ، برآید این دلبر مست

با ساغر پر فتنهٔ پر شور بدست

گر بستانم ، قـــــدح به عقل شکست

ور نستانم ، ندانم از دستش رست

❖

Har rooz beno, baraayad een delbar-e mast
Baa saaghar-e por fetneye, por shoor bedast
Gar bestaanam, gharabeye agh'l shekast
Var nastaanam, nadaanam az dastash rast

❖

*every | day | anew | comes out | this | drunken | sweetheart*
*with | cup of | full | of passion | full | of excitement | in her hands*
*If | I accept | flask of | the intellect | will break*
*and if | I don't accept | I won't know | of | her hands | peace of mind*

❖

Every day, the sweetheart appears anew
With a cup full of passion and excitement in her hands.
If I accept, the flask of intellect will crack,
If I don't, she won't let me be in peace.

285 AK

چشمی دارم همه پر از صورت دوست
با دیده مرا خوشت چون دوست در او

از دیده و دوست فـــرق کردن نیکوست
یا دوست بجای دیده یا دیده خود او

❖

Cheshmee daaram, hame por az soorat-e doost
Baa-deedeh ma-raa khosh ast, chon doost daroost
Az deedeh-o doost, farghkardan na nekoost
Yaa doost bejaaye deedeh, yaa deedeh khodoost

❖

*these eyes | I have | all | full | of | face of the | Beloved*
*with the sight | to me | pleasing | it is | because | the Beloved | is in it*
*of | the sight and | the Beloved | to differentiate | is not | good/fitting*
*either | the Beloved | in the place of | the sight | or | the sight | is him*

❖

My eyes are full with the face of the Beloved.
I am happy with the sight, because I see the Beloved.
There is no difference between the sight and the Beloved.
Either the Beloved is in the sight, or the sight in the Beloved.

300 UT

این بانگ خوش از جانب کیوان منست
این بوی خوش از گلشن و بستان منست

آن چیزی که او بر دل و بر جان منست
تا بر رود او، کجا رود؟! آن منست

Een baang-e khosh, az jaaneb-e keivaan-e manast
Een booye khosh, az golshan-o bostaan-e manast
Aan cheez ke oo, bardel-o bar jaan-e manast
Taa barravad oo, kojaa ravad? aan-e manast

this | thunder of | great | is | of the direction | the Saturn | of mine
this | smell of | great | is | of the garden and | the flower field | of mine
that | thing | which | he [is] | on my heart and | on | my soul | of mine
until | goes | he | where | he goes | that is | of mine

This great thunder is coming from my Saturn.
This fragrance comes from my garden.
He is that Thing which is on my heart and soul.
Until He goes—where can He go? He is mine.

304 AK

در دایرهٔ وجود موجود پی علی است

اندر دو جهان مقصد و مقصود پی علی است

گر خانهٔ اعتقاد ویران نشدی

من فاش بگفتمی که معبود پی علی است

❖

Dar daayereye vojood, mojood Aleest
Andar do jahaan, maghsad-o maghsood Aleest
Gar khaaneye e'teghaad, veeraan nashoodee
Man faash begoftamee ke, ma'bood Aleest

❖

in the | circle of | being | exists | Ali it is
in the | two | worlds | the destination and | the desire-goal | Ali it is
if | the house of | faith/conviction | destroy | has not become for you
I | honestly | speak to you | that | deity/object of worship | Ali it is

❖

In the realm of being, exists only Ali.
In both worlds, the journey and the goal, are only Ali.
If the house of your faith has not yet been destroyed,
Let truth be told, the only one worthy of worship is Ali.

در راه طلب، عاقل و دیوانه یکیست

در شیوهٔ عشق خویش و بیگانه یکیست

آنراکه شراب، وصل جانان دادند

در مذهب، او کعبه و بتخانه یکیست

Dar raah-e talab, aaghel-o divaane yekeest
Dar sheeveye eshgh, kheesh-o bigaane yekeest
Aanraa ke, sharaab-e vasl-e jaanaan daadand
Dar maz'hab-e oo, ka'be-o bot<u>khaa</u>ne yekeest

*in the | path of | seeking-searching | the wise one and | the mad | are one*
*in the | style-discipline of | love | relatives and | strangers | are one*
*that one | who | the wine of | union of | the supreme soul | they have given*
*in the | religion of | him | the ka'be and | a temple of idols | are one*

In the path of union, the wise man and the mad man are one.
In the way of love, close friends and strangers are one.
That one who has tasted the wine of union with the supreme soul,
In his faith, the Ka'be and an idol temple are one.

311 AK

در عشق که جز می بقا خوردن نیست

جز جان دادن دلیل جان بردن نیست

گفتم که ترا اشناسم آنگه میرم

گفتا که شناسای مرا مردن نیست

❖

Dar eshgh, ke joz mey-e baghaa, khordan neest
Joz jaan daadan, daleel-e jaan bordan neest
Goftam ke, "Toraa shenaasam, aangah meeram"
Goftaa ke, "Shenaasaaye ma-raa, mordan neest"

❖

*in | love | which | except | wine of | timelessness/immortality | drinking | there is not*
*except | life | giving | reason of | life | carrying | there is not*
*I said | that | you | I know | then | I die*
*he said | that | knowing of | me | dying | it has not*

❖

In love, aside from sipping the wine of timelessness, nothing else exists.
There is no reason for living except for giving one's life.
I said, "First I know you, then I die."
He said, "For the one who knows Me, there is no dying."

318 UT

این سینه پر مشغله از مکتب اوست
و امروز که بیمار شدم از تب اوست

پرهیز کنم زهر چه فرمود طبیب
جز از می و شکری که آن از لب اوست

❖

Een seeneye por mash<u>a</u>le, az maktabe oost
Va emrooz ke beemaar shodam, az tab-e oost
Parheez konam, ze harch-e farmood tabeeb
Joz az mey-o shekaree ke, aan az lab-e oost

❖

*this | chest of | full of | flames | of | school of | he is*
*and | today | that | ill | I have become | of | fever of | he is*
*stay away | I will do | of | anything | commanded | the doctor*
*except | of | the wine and | the sugar | which | that | of | lips of | he is*

❖

This chest, so full of flames, is a lesson of His school.
And today my illness is His fever.
I'll stay away from what the doctor recommends
Except for the wine and sugar which spills from His lips.

319 UT

<div dir="rtl">

بر هر جایی که سر نهم ، مسجود اوست

در شش جهت و برون شش ، معبود اوست

باغ و گل و بلبل و سماع و شاهد

این جمله بهانه ست ، همه مقصود اوست

</div>

<div align="center">◈</div>

Bar har jaayee ke sar naham, masjood oost
Dar shesh jahat-o, beroon-e shesh, ma'bood oost
Baagh-o gol-o bolbol-o, samaa'o shaahed
Een jomle bahaane ast, hame maghsood, oost

<div align="center">◈</div>

*at | any | place | that | head | I place | cushion | he is*
*in | six | directions and | out of | six | deity | he is*
*garden and | flower and | nightingale and | samaa (whirling) and | the witness/companion*
*this | all together | an excuse | it is | all | intention/goal | he is*

<div align="center">◈</div>

Any spot that I place my head, He is the cushion.
In all the six directions and out, He is the deity.
Garden, flower, nightingale, samaa, and a companion.
These are all an excuse. He is my only reason.

319 AK

دروصل جمالش گل خندان منست

درهجر خیالش دل و ایمان منست

دل بامن و من بادل ازآن در جنگم

هر یک گوئیم آن صنم آن منست

Dar vas'l, jamaalash gol-e khandaan-e manast
Dar hej'r, khiyaalash del-o eemaan-e manast
Del baaman-o, man baa del, az aan dar jangam
Har yek gooyeem, aan sanam, aan-e-manast

*in | union/marriage | his face | rose/flower of | laughing of | mine it is*
*in | separation | the thought of him | heart and | faith of | mine it is*
*heart | with me and | I | with | the heart | for | him | in | dispute/fight I am*
*every | one of us | we say | that | idol | is mine*

In the marriage of our soul, His face is my laughing flower.
In separation, the thought of Him is my heart and reason.
The heart and I are always fighting over Him.
Both of us say, "That idol belongs only to me."

321 UT

اندر دل من درون و بیرون همه اوست
اندر تن من جان و رگ و خون همه اوست

اینجای چگونه کفر و ایمان گنجد؟!
بی چون باشد وجود من چون همه اوست

Andar deleman, daroon-o biroon hame oost
Andar taneman, jaan-o rag-o khoon, hame oost
Injaay chegoone, kofr-o eemaan gonjad?
Bee choon baashad vojood-e man, chon hame oost

*in the middle | of my heart | inside and | out side | all | he is*
*in the middle | of my body | soul/life and | veins and | blood | all | he is*
*this place | how can | infidelity and | faith | fit/contain*
*without | value | it is | life of | me | because | all | he is*

Inside and outside, he surrounds my heart.
My body, my soul, my veins and my blood, are all Him.
How can blasphemy and faith fit into my being?
My life has no value, for He is everything.

329 UT

ای ذکر تو مانع تماشای تو دوست

برق رُخ تو نقاب سیمای تو دوست

با یاد لبت از لب تو محرومم

ای یاد لبت حجاب لبهای تو دوست

◈

Ey zekr-e to, maane'e tamaa<u>shaa</u>ye to doost
Bargh-e rokh-e to, neghaab-e seemaaye to doost
Baa yaad-e labat, az lab-e-to mahroomam
Ey yaad-e labat, hejaab-e lab<u>haa</u>ye to doost

◈

*O | remembrance of | you | barrier of | looking at | you | friend/Beloved*
*glow of | face of | you | mask of | face of | you | friend/Beloved*
*with | the thought of | your lips | of | your lips | I am deprived*
*O | the thought of | your lips | veil of | lips of | you | friend/Beloved*

◈

The memory of you blinds my vision of you, O Beloved.
The glow of your face is the mask of your face, O Beloved.
The thought of your lips, deprives me of your lips
The thought of your lips, is the veil of your lips, O Beloved.

336 AK

ديوانه شدم خواب ز ديوانه خطاست

ديوانه چه داند كه ره خواب كجاست

زيرا كه خدا نخفت و پاكست ز خواب

مجنون خدا بدان هم از خواب جداست

◈

Divaane shodam, khaab że divaane kha<u>taa</u>st
Divaane che daanad, ke rah-e khaab kojaast
Ziraa-ke, khodaa nakhoft-o, paakast ze khaab
Majnoon-e khodaa, bedaan ham az khaab jodaast

◈

mad | I have become | sleep | from | a mad person | is wrong (not expected)
mad [person] | how | [would] he know | that | path of | sleep | which way it is
because | God | does not sleep and | pure/free he is | of | sleep
[the one] crazy for | God | you know | also | of | sleep | he is separate

◈

I have become mad—how can you expect me to sleep?
How could a mad person find a way to sleep?
Because God does not sleep, He is free from it.
One who is crazy for God, also does not sleep.

344 AK

<div dir="rtl">
زان سے می خوردم که روح پیمانه اوست
</div>

<div dir="rtl">
زان مست شدم که عقل دیوانه اوست
</div>

<div dir="rtl">
شمعی به من آمد آتشے سے درمن زد
</div>

<div dir="rtl">
آن شمع که آفتاب پروانه اوست
</div>

❖

Zaan mei khordam, ke rooh pei<u>maa</u>neye oost
Zaan mast shodam, ke agh'l divaa<u>ne</u>ye oost
Sham'ee beman aamad, aatashee dar man zad
Aansham', ke aafetaab parvaa<u>ne</u>ye oost

❖

*of that | wine | I drank | which | the soul | cup of | him it is*
*of that | drunk | I have become | which | intellect | crazy about | him it is*
*a candle/light | to me | it came | a flame/fire | in | me | it evoked/kindled*
*that candle | which | the sun | butterfly of | him it is*

❖

I drank that wine of which the soul is its vessel.
Its ecstasy has stolen my intellect away.
A light came and kindled a flame in the depth of my soul.
A light so radiant that the sun orbits around it like a butterfly.

351 UT

تا در دل من صورت آن رشک پریست

دلشاد چو من ، درین همه عالم کیست

والله که بجز شاد ، نمی دانم زیست

غم می شنوم ، ولی نمی دانم چیست

◈

Taa dar del-e man, soorat-e aan rashk pareest
Delshaad cho man, dar een hame aalam keest?
Vaallaah ke bejoz shaad, nemidaanam zeest
Gham meeshenavam, valee nemidaanam cheest

◈

*until | in | heart of | mine | face of | that | enviable | angel there is*
*joyous | like | me | in | this | all | the world | who is*
*I swear | that | except | joyful | I don't know how | to exist*
*sorrow | I hear | yet | I don't know | what it is*

◈

As long as the face of that enviable angel is in my heart,
Who is happy as me in all this universe?
I swear, I only know how to live blissfully,
I hear about sorrow but I have no idea what it is.

353 AK

شاگرد تو است دل که عشق آموز است

مانندهٔ شب گرفته پای روز است

هر جا روم صورت عشق است به پیش

زیرا روغن در پی روغن سوز است

❖

shaagerd-e tost del, ke eshgh aamooz ast
Maa<u>nan</u>deye shab, gerefte paaye roozast
Harjaa ke ravam, soorat-e eshghast bepeesh
Zeeraa roghan, dar pey-e roghan sooz ast

❖

*student of | you it is | the heart | because | love | learning (studying love) | it is*
*like the | night | grabbing hold of | the feet of | day it is*
*any place | that | I go | the face of | love is | ahead/in front*
*because | oil/fuel | in | search of | oil | burner | it is*

❖

The heart is your student—it has come to learning on love.
Like the night it's grabbing hold of the daylight's feet.
Any where I go, the face of love is in front of me.
Like oil forever in search of an oil lamp.

366 UT

Baa hasti-o nees<u>ti</u>am, begaa<u>ne</u>geest
Vaz hardo boree<u>da</u>nam, na-mardaa<u>ne</u>geest
Gar man ze ajaa<u>ye</u>bee, ke dar del daaram
Divaane nemee<u>sha</u>vam, ze-divaa<u>ne</u>geest

*with | existence and | non existence of mine | it is all alienation*
*and of | the two | me cutting from [them] | it is not chivalry/noble*
*if | I | of | wonders | that | in | [my] heart | I have*
*mad | I don't become | it is of madness*

Both existence and nonexistence are alien to me,
Yet escaping from the two is not a noble deed.
If from the wonders I have in my heart
I don't become mad, it is because of madness itself.

411 UT

تا مهر نگار با وفایم بگرفت

پس بودم، او چو کیمیایم بگرفت

او را به هزار دست جویان گشتم

او دست دراز کرد و پایم بگرفت

❖

Taa mehr-e negaar-e baa<u>va</u>faayam, begereft
Mes boodam, oo cho keemi<u>yaa</u>yam begereft
Oo-raa behezaar dast, jooyaa gashtam
Oo dast deraaz kard-o, paayam begereft

❖

*when | the kind | glance of | my devoted one | it caught [me]*
*copper | I was | he | like | alchemy me | it caught*
*him | with a thousand | hands | searched | I did*
*he | hands | stretch | did and | my feet | he caught*

❖

When the sweet glance of my true love caught my eyes,
Like alchemy, it transformed my copper-like soul.
I searched for Him with a thousand hands,
He stretched out His arms and clutched my feet.

422 AK

من محو خدایم و خدا آن منست
هر سوش مجوئید که در جان منست

سلطان منم و غلط نمایم شما
گویم که کسی هست که سلطان منست

◈

Man mahv-e khodaa<u>yam</u>-o, khodaa aan-e manast
Har soosh ma<u>joo</u>eed, ke dar jaan-e manast
Soltaan manam-o, ghalat namaayam beshomaa
Gooyam ke kasee hast, ke soltaan-e manast

◈

*I [have] | disappeared | in God and | God | that of | mine he is*
*any | direction | don't look [for him] | because | in the | soul of | mine he is*
*sultan | I am and | wrong | I would say | to you*
*[if] I say | that | some one | there is | who | sultan of | mine he is*

◈

I have lost myself in God, and now God is mine.
Don't look for Him in every direction, for He is in my soul.
I am the Sultan. I would be lying
If I said that there is someone who is my Sultan.

424 AK

میگریم زار و یار گوید زرقست

چون زرق بود که دیده درخون غرقست

تو پنداری که هر دلی چون دل تست

نی نی صنما میان دلها فرقست

◈

Meegeryam zaar-o, yaar gooyad zarghast
Chon zargh bovad, ke deedeh dar khoon gharghast
To pendaari ke, har delee chon del-e tost
Nee nee sanamaa, miyaan-e delhaa farghast

◈

*I cry | bitterly and | the lover | he says | its garish*
*what | garish | it is | which | face | in | blood | has drawned*
*you | think | that | every | heart | like | heart of | yours it is*
*no | no | my idol | between | the hearts | there is a difference*

◈

I cry bitterly and the lover calls it an empty show.
Is it an empty show, that my face has drowned in blood?
You think that every heart is like yours?
No, no, my sweet one, not all hearts are the same.

435 UT

Andar del-e beevafaa, gham-o maatam baad
Aanraa ke vafaa neest, ze aalam kam-baad
Deedi ke maraa, heech<u>ka</u>see yaad nakard
Joz gham, ke hezaar aafareen bar gham baad

◈

*in the | heart of | faithless | sorrow and | grief | there is*
*the person | who | faith | has not | of | the world | he is less (short changed by life)*
*did you see | that | me | no one | remember | didn't*
*except | sorrow | which | a thousand | praises | on | sorrow | be it*

◈

The faithless heart is in grief and sorrow.
One without faith is not truly alive.
Didn't I tell you that no one would remember me
Except for sorrow. A thousand praises to that sorrow.

447 AK

Har-rooz delam, dar gham-e to zaartar-ast
Vaz man del-e beerahm-e to, bizaartar-ast
Bogzaashtiam, gham-e to nagzaasht-maraa
Ha'ghaa ke ghamat, az to vafaadaartar-ast

*every day | my heart | in | the sorrow of | you | more painful it is*
*and with | me | heart of | merciless of | you | more weary it is*
*you have left me alone | sorrow of | you | hasn't left me alone*
*in truth | that | your sorrow | of | you | more dedicated it is*

Every day my heart falls deeper in the pain of your sorrow.
Your cruel heart is weary of me already.
You have left me alone yet your sorrow stays.
Truly, your sorrow is more faithful than you are.

449 UT

عشق آن باشد که خلق را دارد شاد

عشق آن باشد که داد شادیها داد

مارا مادر نزاد ، آن عشق بزاد

صد رحمت و آفرین بر آن مادر باد

<hr>

Eshgh on baashad, ke khalgh<u>raa</u> daarad shaad
Eshgh on baashad, ke daad shaadihaa daad
Maa-raa maadar nazaad, aan eshgh bezaad
Sad rahmat-o, aafareen baraan maadar baad

<hr>

*love | that | is | which | the people | it has/makes | happy*
*love | that | is | which | gave | happiness | gave*
*me/we | mother | didn't give birth to | that | love | did give birth to*
*a hundred | blessings and | praises | to that | mother | be it*

<hr>

It is love that brings happiness to people.
It is love that gives joy to happiness.
My mother didn't give birth to me, that love did.
A hundred blessings and praises to that love.

450 AK

هرگز ز دماغ بنده بوی تو نرفت

وزدیده من خیال روی تو نرفت

در آرزوی تو عمر بردم شب و روز

عمرم همه رفت و آرزوی تو نرفت

Hargez ze damaagh-e bande, booye to naraft
Vaz deedeye man, khiyaal-e rooye to naraft
Dar aarezooye to, omr bordam shab-o rooz
Omram hame raft-o, aarezooye to naraft

*never | of | nose of | mine | smell of | you | left not*
*and of | sight of | mine | thought of | face of | you | left not*
*in the | desire of | you | lifetime | I passed | night and | day*
*my life | all | is gone and | the desire of | you | left not*

Your scent has never left my nose;
The image of your face has never left my sight.
For lifetimes I have longed for you, day and night.
My life is now consumed, yet my desire for you is still the same.

452 UT

Aankas ke bar, aatash-e jahaanam benahaad
Sad goone zabaane, bar zabaanam benahaad
Chon shesh jahatam, sho'leye aatash begereft
Aah kardam-o, dast bar<u>da</u>haanam benahaad

*the person | who | on | fire of | the world me | he placed*
*a hundred | different | blazes | on | my tongue | he placed*
*since | six | directions of mine | flames of | fire | it seized*
*sigh | I did and | hand | on my mouth | he placed*

The one who put me in this world of fire
Placed a hundred flames on my tongue.
Since all six directions were in a blaze,
I yelled out and he put his hand over my mouth!

464 UT

مردی که هست و نیست قانع گردد

هست و عدم اورا همه مانع گردد

موصوف صفات و فعل کی باشد او

کز صنع برون آید و صانع گردد

◈

Mardi ke behast-o neest, ghaane' gardad
Hast-o adam ooraa, hame maane' gardad
Mosoof-e sefaat-o fe'el, kei baashad oo
Kaz san' beroon aayad-o, saane' gardad

◈

*The man | who | with being and | not being | content | would become*
*being and | not | for him | all | obstacle | will become*
*described by | qualities/good thoughts and | action | when | would be | he*
*of | the creation | out | come he and | creator | will become*

◈

True man is content with being and not being,
Concern with being, can only be an obstacle.
How could he be described by good thoughts and deeds,
When he will emerge from creation and become the Creator?

466 UT

مَعْشُوقَه چو آفتاب، تابان گردد؛
عاشق به مثال ذره، گردان گردد

چون باد بهار عشق جنبان گرد
هر شاخ که خشک نیست رقصان گرد

❖

Ma'shooghe cho aftaab, taabaan gardad
Aashegh bemesaal-e zarreh, gardaan gardad
Chon baade bahaar-e eshgh, jonbaan gardad
Har shaakh ke khoshk neest, raghsaan gardad

❖

*The lover/mistress | like | the sun | radiating | will become*
*The lover | similar to | particles | revolving | will become*
*Because | breeze of | spring of | love | shake | it will*
*Every | branch | that | dry | is not | dancing | will become*

❖

The lover like the sun will shine.
The lover like the atoms will turn.
When the spring breeze of love begins to swirl,
Any branch that is not dead will dance.

479 UT

در یار نظره کنم، خجل می گردد
ور ننگرمش، آفت دل می گردد

در آب رخش ستارگان پیدا اند
بی آب وی، آبم همه گل می گردد

⬦

Dar yaar nazar konam, khejel meegardad
Var nangeramash, aafat-e del meegardad
Dar aab-e rokhash, setaaregaan peidaayand
Bee aab-e vey, aabam hame gel meegardad

⬦

*In | the lover | gaze/look | I do | shameful/red in the face | becomes*
*and if | I don't look at him | pain/virus | [in the] heart | becomes*
*In the | water of | his face | stars | are visible*
*with out | water of | him | my water | all | mud | becomes*

⬦

I look at the Beloved, and His face turns red.
And if I don't look He causes my heart to ache.
In the pool of His face stars are visible
Without His water, my water is nothing but mud.

485 AK

Aansar ke bovad, beekhabar az mei khospad
Aankas ke khabar yaaft az oo, kei khospad
Meegooyad eshgh, dar do goosham hame shab
Ey vaay bar aan<u>ka</u>see, ke bee vey khospad

*that head (person) | who | is | ignorant | of | wine | fall sleep*
*that person | who | news | received | of | him | when | can he fall sleep*
*says | love | in | both | my ears | all | night*
*O | grief | on | the person | who | with out | him | falls sleep*

Can one who has not tasted wine fall asleep?
The one who hears news of Him, how then can he sleep?
Love whispers in my ears all night.
Only grief comes to one who falls asleep without Him.

492 AK

آنکس که ترا شناخت جان را چه کند

فرزند و عیال و خانمان را چه کند

دیوانه کنی هر دو جهانش بدهی

دیوانه تو هر دو جهان را چه کند

◈

Aankas ke to-raa shenaa<u>kh</u>t, jaanraa che konad
Farzand-o ayaal-o khaane<u>maan</u>-raa, che konad
Divaane konee, har do jahaanash bedahee
Divaaneye to, har do jahaan-raa che konad

◈

*the one | who | you | he knows | life | what | to do about*
*the children and | wife and | the livelihood | what | to do about*
*mad | you turn | both | two | worlds | you give*
*mad for | you | both | two | worlds | what | to do about*

◈

Does life have any meaning to one who has found you?
Do wife, children, and livelihood have any meaning?
You turn people mad and then offer the two worlds.
Does the world have any meaning for one maddened by your love?

508 UT

بیت و غزل و شعر مرا آب ببرد

رختی که نداشتیم ، سیلاب ببرد

نیک و بد و زهد و پارسایی مرا

مهتاب ، بداد و باز مهتاب ببرد

Beit-o ghazal-o, she're maraa aab bebord
Rakhtee ke nadaa<u>sh</u>teem, seilaab bebord
Neek-o bad-o zahd-o, paar<u>saa</u>eeye maraa
Mahtaab bedaad-o, baaz mahtaab bebord

verses and | love songs and | poems | of mine | water | took
clothes | which | I didn't [even] have | flood | took
good and | bad and | asceticism and | Persian-ness | of mine
moonlight | gave/caused and | again | moonlight | took [away]

My verses, love songs, and poems were taken by the water.
The clothes that I didn't even own were taken by the flood.
Good, bad, asceticism, and my Persian blood
Moonlight gave, and again, moonlight took away.

511 UT

عشق تو سلامت ز جهان می برد

هجر تو اجل گشت که جان می برد

آن دل که به صد هزار جان می ندهند

یک خنده تو، برایگان می برد

Eshgh-e to, salaamat ze jahaan meebarad
Hejr-e to ajal gasht, ke jaan meebarad
Aan del ke, besad hezaar jaan meena<u>da</u>hand
Yek khandeye to, ber<u>aa</u>yegaan meebarad

*love of | you | health | of | the world | it takes/steals*
*separation of | you | death | it became | that | life | it takes/steals*
*that | heart | which | with one hundred | thousand | life | they don't give*
*one | smile of | you | for free | it takes/steals*

Your love robs the world of its health.
Separation from you becomes the death that steals life.
The heart, which they wouldn't give even for a thousand lives,
That, your one smile takes for free.

511 AK

از آب حیات دوست بیمار نماند

در گلبن وصل دوست یکخار نماند

گویند دریچه‌ایست از دل سوی دل

چه جای دریچه‌ای که دیوار نماند

---

Az aab-e-hayaat-e doost, beemaar namaand
Dar golbon-e vasl-e doost, yekkhaar namaand
Gooyand dareecheist, az del sooy-e del
Che jaaye dareeche'ee, ke divaar namaand

---

*of | water of life of | the friend/Beloved | ill person | didn't remain*
*in | the rose garden of | union of | the friend/Beloved | one thorn | didn't remain*
*they say | there is a window | from | a heart | toward a | heart*
*what |a place for | a window | where | a wall | didn't remain*

---

With the Beloved's water of life, no illness remains
In the Beloved's rose garden of union, no thorn remains.
They say there is a window from one heart to another
How can there be a window where no wall remains?

512 AK

ازآتش سودا پےے توام تابی بود

درجوی دل ازصحبت توآبی بود

آن آب سراب بود وآن آتش برف

بگذشت کنون قصّه مگرخوابی بود

◈

Az aatash-e sodaaye tavaam, taabee bood
Dar jooye del, az sohbat-e to, aabee bood
Aan aab saraab bood-o, aan aatash barf
Bogzasht konoon ghesse, magar khaabee bood

◈

*of | the fire of | passion of | the twins | a glow/red hot | there was*
*in the | stream of | the heart | of | the conversation of | you | water | there was*
*that | water | a mirage | it was and | that | fire | snow*
*passed | now | the story/fable | as if | a dream | it was*

◈

There was a red hot glow when the twins joined together.
There was the sound of your voice in the stream of the heart.
Pure water is now a mirage, blazing fire cold like snow,
The legend of life is now passed—was it just a dream?

519 UT

Ham kofram-o, ham deenam-o, ham saafam-o dord
Ham peeram-o, ham javaan-o, ham koodak-e khord
Gar man bemoram, maraa magooeed ke, "Mord"
Goo, "Mordeh bod-o, zendeh shod-o, doost bebord"

*also | blasphemy and | also | religion and | also | pure/filtered and | dregs*
*also | old and | also | young and | also | child | small*
*if | I | die | to me/about me | don't say | that | he died*
*say | dead | he was and | alive | became and | the friend/Beloved | took him*

I am blasphemy and religion, pure and unpure;
Old, young, and a small child.
If I die, don't say that he died.
Say he was dead, became alive, and was taken by the Beloved.

521 AK

Az shabnam-e eshgh, khaak-e aadam gel-shod
Sad fetne-o shoor, dar jahaan haasel-shod
Sad neshtar-e eshgh, bar rag-e rooh zadand
Yek ghatreh az aan chekido, naamash del-shod

*of | dew drops of | love | the soil of | Adam | turned mud (became a body)*
*a hundred | seductions and | sensations | in | the world | was produced*
*a hundred | cuts-lances of | love | at the | vein of | the soul | they hit*
*one | drop | of | that | leaked and | its name | became the heart*

All it took was the dew drops of love to form Adam's body of mud.
A few drops and a universe of seductions and sensations was set.
It brought down a hundred lances of love on the veins of the soul
One drop leaked and became what we call "the heart."

522 AK

ازشربت سودای تو هر جان که مزید

زان آب حیات در مزید است مزید

مرگ آمد و بو کرد مرا بویِ تو دید

زان روی اجل امید از من ببرد

Az sharbat-e sodaaye to, har jaan ke mazeed
Zaan aab-e hayaat, dar mazeedast mazeed
Marg aamad-o boo-kard maraa, booye to deed
Zaanrooy, ajal, omeed az man beboreed

*of | sweet drink/sorbet of | passion of | you | any | soul | that | increased/elevated*
*of that | water of | life | in | elevation/elation he is | elevation/elation*
*death | came and | smelled | me | the smell of | you | he saw/sensed*
*because of that | death | hope | from | me | it cut of*

Any soul that drank the nectar of your passion was lifted.
From that water of life he is in a state of elation.
Death came, smelled me, and sensed your fragrance instead
From then on, death lost all hope of me.

547 UT

Yaad-e to konam, delam tapeedan geerad
Kho<u>naa</u>be ze deedegaan, chekeedan geerad
Harjaa khabar-e doost, reseedan geerad
Beechaareh delaam, ze tan pareedan geerad

*thought of | you | I do | my heart | to pound | it starts*
*blood water | of | faces | to drip | it starts*
*any place | news of | the Friend | to arrive | it starts*
*poor | my heart | of | the body | to fly | it starts*

When I think of you my heart starts to pound.
Tears of blood drip down my face.
When news from the Friend is first heard,
My poor heart lifts up from the body toward the sky.

550 UT

این شهائے هزار جان بیش ارزد
این آزادیے ملک جهان بیش ارزد

در خلوت، یکزمانه باحق بودن
از جان و جهان و این و آن بیش ارزد

❖

Een tan<u>haa</u>ee, hezaar jaan beesh arzad
Een aa<u>zaa</u>dee, molk-e jahaan beesh arzad
Dar khalvat, yek<u>za</u>maane baa hagh boodan
Az Jaan-o, jahaan-o, een-o aan, beesh arzad

❖

*this | aloneness | one thousand | souls | more | it is worth*
*this | freedom | land of | the world | more | it is worth*
*in | solitude/retreat | a moment | with | the truth/God | to be*
*of | life and | world and | this and | that | more | it is worth*

❖

This aloneness is worth more than a thousand lives.
This freedom is worth more than all the lands on earth.
To be one with the truth for just a moment,
Is worth more than the world and life itself.

557 UT

<div dir="rtl">

از عشق تو آتش جوانی خیزد؛

در سینه جمالهای جانی خیزد

گرمی کشیم بکش، حلالست ترا

کز کشتن دوست زندگانی خیزد

</div>

Az eshgh-e to, aatash-e javaanee kheezad
Dar seene, jamaal<u>haa</u>ye jaanee kheezad
Gar miko<u>shee</u>am bekosh, halal ast toraa
Kaz koshtan-e doost, zende<u>gaa</u>nee kheezad

*of | love of | you | fire of | youth | will rise*
*in | chest | images/faces of | life | will rise*
*if | you will kill me | kill | lawful | it is | for you*
*because of | the killing of | the friend | [a new] life/living | will rise*

Out of your love the fire of youth will rise.
In the chest, visions of the soul will rise.
If you are going to kill me, kill me, it is all right.
When the friend kills, a new life will rise.

577 UT

سودای ترا بهانه بس باشد

مدهوش ترا ترانه بس باشد

در کشتن ما چه می زنی تیغ جفا

ما را پس تازیانه بس باشد

◈

So'daaye toraa, bahaane'i bass baashad
Mad'hoosh-e toraa, taraane'i bass baashad
Dar koshtan-e maa, che meezanee teegh-e jafaa?
Maa-raa sar-e taa<u>ziyaa</u>ne'i, bass baashad

◈

*passion of | you | a reason/excuse | enough | is*
*drunkenness of | you | a song | enough | is*
*in | killing of | me | why | hit/strike | blade of | unkindness*
*for me | tip/touch | of a whip | enough | is*

◈

Your passion is just an excuse.
Your drunkenness is just a song.
Why do you strike me with the blade of unkindness,
When only the touch of a whip is enough?

579 UT

بوی دم مقبلان چو گل خوش باشد
بدبخت، چو خار، تیز و سرکش باشد

درصحبت گل خار زآتش برهد
وز صحبت خار گل در آتش باشد

◈

Booy-e dam-e mogha<u>bel</u>aan, cho gol khosh baashad
Badbakht, cho khaar, teez-o sarkesh baashad
Dar soh<u>bat</u>-e gol, khaar, ze aatash berahad
Vaz soh<u>bat</u>-e khaar, gol dar aatash baashad

◈

*scent of | breath of | fortunate ones | like | flower/rose | pleasant | is*
*the unfortunate | like | thorn | sharp and | long/pointed | is*
*in | the conversation of | flower/rose | thorn | of | fire | will escape*
*and of | the conversation of | thorn | flower/rose | in | fire | is*

◈

The breath of the fortunate ones is fragrant as a rose.
And of the unfortunate it is sharp like a thorn.
Speaking of roses, the thorn will escape from the fire.
Speaking of thorns, a rose will remain in the fire.

616 UT

تا در دل من عشق تو افروخته شد

جز عشق تو هر چه داشتم سوخته شد

عقل و سبق و کتاب بر طاق نهاد

شعر و غزل و دوبیتی آموخته شد

Taa dar del-e man, eshgh-e to afrookh<u>te</u> shod
Joz eshgh-e to, har che daashtam sookhte shod
Aghl-o, sabagh-o, ketaab bar taagh nahaad
She'er-o ghazal-o dobeity, aamookh<u>te</u> shod

*when | in | heart of | mine | love of | you | set ablaze | it did*
*except | love of | you | all | that | I had | burned | it did*
*intellect and | excellence and | book | on | shelf | it placed*
*poem/poetry and | love song and | couplets | learned | it did*

When your love set my heart ablaze,
All that I had turned ashes, except for your love.
Intellect, achievement, and books were placed on the shelves—
Poetry, love songs, and couplets were learned instead.

646 UT

من بی خبرم، خدای حق می داند
کندر دل من مراچه می خنداند

باری دل من شاخ گلی را ماند
کش باد صبا بلطف می افشاند

◈

Man beekhabaram, khodaaye hagh meedaanad
Kandar del-e man, ma-raa che meekhandaanad
Baaree, deleman shaakh-e goleeraa maanad
Kash baad-e sabaa belotf, meeafshaanad

◈

*I | am not aware | the God of | truth | knows*
*that in | heart of | mine | me | why | makes me laugh*
*any how | my heart | stem of | a flower | it resembles*
*which | breeze of | morning | out of kindness | shakes about*

◈

I am blind to the truth, only God knows,
Why He is making me laugh in my heart.
My heart resembles a stem of a flower
Which the morning breeze gently shakes about.

650 AK

Khaaham gardee, ke az ha<u>vaa</u>ye to resad
Baashad ke be<u>dee</u>deh, khaak-e paaye to resad
Jaanam ze jafaa, khorramo khandaan baashad
Zeera ze jafaa, booye vafaaye to resad

*I want | the particles | that | of | air/the being of | you | it reaches*
*let it be | that | to the sight/eyes | the dust of | feet of | you | it reaches*
*my life | of | unkindness | delightful and | joyous | it is*
*because | of | unkindness | the smell of | faithfulness of | you | it reaches*

I want the particles that come from your being.
Let the sight always bathe in the dust of your feet.
I am joyous and cheerful at the Beloved's cruelty.
It is the cruelty that confirms the Beloved's loyalty.

651 AK

خواهم که دلم با غم همخو باشد

گر دست دهد غمش چه نیکو باشد

هان ای دل بیدل غم او در بر گیر

تا چشم زنی خود غم او او باشد

---

Khaaham ke delam baa gham, ham-khoo baashad
Gar dast dahad ghamash, che-nikoo baashad
Haan ey del-e-beedel, gham-e oo dar bar geer
Taa chesh'm-zanee, khod-gham-e oo, oo baashad

---

*I desire | that | my heart | with | sorrow | congenial/one kind | it would be*
*if | hand | gives | his sorrow | how great | it would be*
*beware | O | the heartless heart (free of passions) | sorrow of | him | in | bosom |*
*behold*
*until | you blink an eye | the sorrow of | him | himself | it would be*

---

I wish my heart to be one with sorrow.
What wonder to feel the hand of His sorrow!
Know this, O heartless heart, and behold His sorrow.
Before long, you will learn that His sorrow is indeed His true self.

655 UT

Mahraa tarafee, berooye oo meemaanad
Chizeesh bedaan, fereshtekhoo meemaanad
Nee nee, ze kojaa taa bekojaa? Mah ke bood?
Jaan bandeye oo, bedoo, khodoo meemaanad

*the moon | one side of | face of | him | it resembles*
*something of it | to that | angel like disposition (the Beloved) | it resembles*
*no | no | from | where | to where | moon | who | is*
*[my] life | servant/slave of | him | him to | himself | it resembles*

One side of the moon resembles His face.
There is something about the moon that resembles the Beloved.
No, no, from where to where? What moon?
My life is in service to Him, the Beloved only resembles Himself.

656 AK

خون دل عاشقان چو جیحون گردد

عاشق چو کفی بر سر آن خون گردد

جسم تو چو آسیا و آبش عشق است

چون آب نباشد آسیا چون گردد

◈

Khoon-e del-e aa<u>sh</u>eghaan, cho jeyhoon gardad
Aashegh cho kafee, barsar-e aan<u>khoo</u>n gardad
Jesm-e to cho aasi<u>yaa</u>v-o, aabash eshgh ast
Chon aab nabaashad, aasiyaa chon gardad

◈

*the blood of | heart of | lovers | like | Oxus River | it will become*
*lover | like | foam | on top of | that blood | it will become*
*the body of | you | like | a mill it is and | its water | love | it is*
*if | water | does not exist | the mill | how | [can it] turn*

◈

The blood from the lover's heart, will flow like the Oxus River
And the lover will be that foam covering the stream of blood.
You are a wheel and love is water
Is it possible for a water wheel to turn without water?

673 AK

Dar eshgh, agar damee gharaarat-baashad
Andar saf-e aasheghaan, che kaarat baashad
Sar teez cho khaar baash, taa yaar-e cho gol
Gah dar bar-o, gaah bar kenaarat baashad

*in | love | if | [for] a moment/a breath | you feel comfortable/stable*
*in the | queue/line of | lovers | what | business/purpose | do you have*
*head | sharp (shrewd-steadfast) | like | a thorn | become | until | the lover | [who is] like a flower/rose*
*at times | in | [your] bosom/arms | at times | at | your side | he will be*

On the path of love, if you find rest for even a moment
Then what business do you have lining up with the lovers?
Sharp and hard like a thorn, then approach the Beloved delicate as a rose
So you can hold Him in your arms and have Him by your side.

678 AK

<div dir="rtl">

در کوی خرابات تکبر نخرند

مردی بسرکوی خرابات برند

آنجا چو رسے مقامری باید کرد

یا مات شوے یا بری یا برند

</div>

Dar kooy-e kha<u>raa</u>baat, takabbor nakharand
Mardi, besar-e-kooy-e kha<u>raa</u>baat, barand
Aanjaa cho resee, moghaa<u>me</u>ree baayad kard
Yaa maat shavee, yaa bebaree, yaa bebarand

*in the | alley of | ruins/selflessness | arrogance | they won't buy*
*manliness/lack of pretention/self-respect | in the alley of | ruins | they take (they honor these qualities)*
*there | when | you reach | gambling | [one] has to | do*
*either | checkmate | you become | or | you win | or they win*

In the alley of selflessness, arrogance has no value.
What sells the best is self-respect and honesty.
When you get there be prepared to gamble
For either you are checkmated and they win, or you win.

679 AK

Dar lashkar-e eshgh, chonk-e khoonreez konand
Shamsheer ze paare<u>haa</u>ye-maa, teez konand
Man ghar<u>ghe</u>ye aan seeneye, daryaa sefatam
Yaaraan-e maraa begoo, ke parheez konand

*in the | army of | love | when | blood shed | they do*
*swords | of | our [bodily] pieces | sharpen | they do*
*I | am drowning in | that (his) | bosom of | sea [like] (infinite) | nature*
*[to] the companions of | mine | tell them | that | discrimination/self control | they do*

When the armies of love shed the lovers' blood,
They sharpen their swords with bits and pieces of our bodies.
I have drowned in His bosom, infinite as the ocean,
But remind my companions to practice self-control.

681 UT

هر جا به جهان تخم وفا می کارد

وان تخم زخرمنگه ما می آرند

هر جا ز طرب نای و دفی بردارند

آن شادی ماست، آن خود پندارند

◈

Har jaa bejahaan, tokhm-e vafaa meekaarand
Vaan to<u>khm</u>, ze khar<u>man</u>gah-e maa meeaarand
Har jaa ze tarab, naay-o dafee bardaarand
Aan shaadie maast, aane khod pendaarand

◈

*any | place | in the world | seed of | devotion | they plant*
*and that | seed | of | barn | mine | they bring*
*any | place | of | festivity | reed flute and | frame drum | they use*
*that | happiness of | mine it is | that of | [them] selves | they think*

◈

Anywhere in the world, where seeds of devotion are planted,
They bring the seeds from my barn.
Any place of festivity where a ney and a daf are being played,
That comes from my happiness, though they think it is from their own.

684 AK

---

Dar meikadeye eshgh, cheneen mast ke deed
Khomhaa hame darshekaste-o, past ke deed
Sahn ze meyo, saghf-e falakraa por-e mei
Hamchoon ghadahee, gerefte dar dast ke deed

---

*in the | tavern of | love | like this | drunk | who | saw*
*barrels | all | broken and | lowered | who | saw*
*ground | of | wine and | ceiling of | cosmos | full of | wine*
*such | cup | holding | in | [ones] hand | who | saw*

---

In the tavern of love such drunkards—who has seen?
Barrels all broken and scattered about—who has seen?
The ground is full of wine and the ceiling of heaven is full of wine,
But a cup in anyone's hand—who has seen?

686 AK

Darveesh ke, asraar-e jahaan mi<u>bakh</u>shad
Har dam, molkee be-raa<u>ye</u>gaan mi<u>bakh</u>shad
Darveesh kasee neest ke, naan mitalabad
Darveesh kasee bood ke, jaan mi<u>bakh</u>shad

*darvish | who | the secrets of | the world | he gives away*
*[with] every breath-moment | a piece of land | for free | he gives away*
*darvish | a person | he is not | who | bread | he begs/he asks*
*darvish | a person | he was (is) | who | [his] life | he gives away*

When a darvish spills the secrets of the world
With his every word, he bestows great lands and palaces.
The darvish is not the person who begs his way through
The darvish is the one who surrenders his life in one asking.

693 AK

دلتنگ مشو که دلگشائی آمد
دل نیک نواز بانوائی آمد

غم را چو مگس شکست اکنون پر و بال
کز جانب قاف جان همائی آمد

Deltang masho ke, delgosha'i aamad
Del-neek-navaz, baa navaa'i aamad
Gham-raa cho magas, shekast aknoon par-o baal
Kaz jaaneb-ghaaf, jaan-e homaa'i aamad

*homesick/lonely | don't become | because | [the] heart opener | has come*
*[the one who] treats the heart kindly | with | a melody/sound | has come*
*sorrow | like a | fly | [he] broke | now | feathers and | wings*
*because | from the direction of | Ghaaf (a mystical mountain) | a soul | [like that of] Homaa (mystical bird) | has come*

Don't be so lonely, that heart-opener has come,
With a song, the friend of the heart has come.
He snapped the wings of sorrow as if they belonged to a fly.
His message is, "From Mount Ghaaf the great Homaa has come."

697 AK

دل در پی دلدار بسے باخت نشد
هر خشک و تری که داشت در باخت نشد

بیچاره بکنج سینه بنشست بمکر
هر حیله و فن که داشت پرداخت نشد

Del dar-peye deldaar, basee taakht nashod
Har khoshk-o taree ke daasht, dar-baakht nashod
Beechareh bekonj-e seene, benshast bemak'r
Har hile-vo-fan ke daasht, pardaakht nashod

*heart | in search of | sweetheart | verily/often | galloped/rushed to | [yet] it didn't happen (he was not successful)*
*every | wet and | dry (everything) | that | he had | he lost | [yet] it didn't happen (he was not successful)*
*poor [little thing] | in the corner of | the chest/bosom | he sat | deceitfully*
*any | trick | that | he had | he played | [yet] it didn't happen (he was not successful)*

My heart has been rushing toward the Beloved yet there is no sign of Him.
It has lost every wet and dry thing in this gamble.
The poor thing found a corner in the chest and sat mischievously,
He played all the tricks that he had learned, still there is no sign of Him.

700 AK

دل ها به سماع بیقرار افتادند

چون ابر بهار پرشرار افتادند

ای زهره عیش کف رحمت بگشای

کاین مطرب و کف و دف ز کار افتادند

<hr>

Delhaa besamaa, bigharaar oftaadand
Chon abr-e bahaar, por sharaar oftaadand
Ey zohreye eysh, kaf-e rahmat bogshaay
ke-in motreb-o kaf-o daf, ze kaar oftaadand

<hr>

*hearts | in (because of) samaa | restless | have fallen/become
like | the clouds of | spring | full of | spark/lightning | have fallen/become
O | Venus of | pleasures | palm of | generosity | open
because | the musicians and | hands and | the frame drum | of | work | have
fallen (they are no longer working)*

<hr>

Samaa has made our hearts addicted to turning.
Like the spring clouds, it has filled us with lightning.
O Venus, the source of pleasures, open up your generous palm
For the musicians and the clapping hands have no breath left to move.

704 AK

دوکون خیــال خانه ای بیش نبود
وامد شد ما بهانه ای بیش نبود

عمریست که قصه ای زجان میشنوی
قصه حکنم فسانه ای بیش نبود

Do koon-e khiyaal, khaane'ee beesh nabood
Vaamad shod-e maa, bahaane'ee beesh nabood
Omrees ke, ghesse'ee ze jaan mishenavee
Ghesse chekonam, fesaane'ee beesh nabood

two | mountains of | imagination | a house | more | they weren't
and coming | going of | me | an excuse | more | it wasn't
it has been a life time | that | a story | from | the soul | you are hearing
a story | what can I do (say) | a fairy tale/fantasy | more | it wasn't

In the end, the mountains of imagination were nothing but a house.
And this grand life of mine was nothing but an excuse.
You've been hearing my story so patiently for a lifetime
Now hear this: it was nothing but a fairy tale.

711 AK

Raftam bedar-e khaaneye, aan khosh peyvand
Biroon aamad benazd-e man, khandaakhand
Andar bar-e khod, kesheed neekam chon ghand
K'ey aashegh-o, ey aaref-o, ey daaneshmand

*I went | to the door of | the house of | that | [the one who] pleasantly | unite[s]*
*out | he came | toward | me | laughingly*
*in the| arm of | his | he pulled | me sweetly | like | sugar cubes*
*that O | lover and | O | mystic and | O | scientist/scholar*

I went to the house of the master of union
He came out toward me, laughing.
Pulled me in His arms sweet as sugar cubes,
Saying, "Salaam, O lover, O mystic, O man of science."

720 AK

Roozike ma-raa eshgh-e to, divaane konad
Divaanegi'ee konam, ke deev aan nakonad
Hokm-e mozheh-e to, aan konad baa del-e man
Kaz nok-e ghalam-e, khaajeye divaan nakonad

*that day | to me | love of | you | mad | it does*
*madness | I will do | that | a demon | that [way] | does not do*
*rule of | eyelashes of | you | that | it does | with | heart of | mine*
*that the | tip of | pen of | master of | the Divan (epic poetry collection)| does not do*

The day that I am crazy for your love,
I'll be such a madman that even demons can not compare.
What a blink of your eyelashes does to my heart,
Even the stroke of the pen of the master of Divan can not compare.

722 AK

Ro neeki kon, ke dahr neeki daanad
Oo neekiraa ze neekovaan, nastaanad
Maal az ham-e maand-o, az toham khaahad maand
Aan beh ke, bejaaye maal neeki maanad

go | good deed | do | for | world/time/history | good deed | it knows/ remembers
he | good deeds | of | good people | won't take back (this virtue of kindness)
possessions/commodities | of | everyone | remained | of | you also | it will | remain
it is | better | that | instead of | possessions | good deeds | [should] remain

Go perform good deeds, for that's what history remembers best.
The Beloved won't take back the virtue of kind acts from kind people.
Everyone leaves his possessions behind when he goes, you will too;
It is better that one leaves behind good deeds than great wealth.

723 UT

در حضرت حق ستوده درویشانند

در صدر بزرگ آن منش ایشانند

خواهی که مس وجود تو زر گردد

با ایشان باش، کیمیا ایشانند؛

◈

Dar hazrat-e hagh, setoodeh darvee<u>shaa</u>nand
Dar sadr-e bozorg-e aan manesh, ee<u>shaa</u>nand
Khaahee ke mes-e vojood-e to, zar gardad
Baa eeshaan baash, <u>kee</u>miyaa ee<u>shaa</u>nand

◈

in | the excellence/highness of | truth | praise worthy | are the darvishes
in | level of | great of | that | path/constitution | are they
if you want | that | copper of | soul of | you | gold | become
with | them | stay | alchemy | are they

◈

In the realm of truth darvishes are worthy of praise.
They walk the highest path.
If you want to turn your copper-like soul into gold
Stay with them, they are the alchemy.

728 AK

زندان تو از نجات خوشتر باشد

نفرین تو از نبات خوشتر باشد

شمشیر تو از حیات خوشتر باشد

ناسور تو از نوات خوشتر باشد

◈

Zendaan-e to, az nejaat khoshtar baashad
Nefreen-e to, az nabaat khoshtar baashad
Shamshir-e to, az hayaat khoshtar baashad
Naasoor-e to, az navaat khoshtar baashad

◈

*prison of | you | of | freedom | better/more pleasing | it is*
*curse of | you | of | sugar candy | better/more pleasing | it is*
*sword of | you | of | life | better/more pleasing | it is*
*unhealable wound of | you | of | eternal health | better/more pleasing | it is*

◈

Your prison is more pleasing than freedom.
Your curse is more pleasing than sugar candy.
The strike of your sword is more pleasing than life.
To receive your fatal wound is more pleasing than eternal health.

731 UT

درکوی تو عاشقـان فزایندورونذ

خون جـگر از دیده گشایندوروند

من بر در تو مقیـم بادام ، چو خاک

ورپنے دگران چو باد آیندوروند

◆

Dar kooy-e to, aasheghaan fhazaayand-o ravand
khoon-e-jegar az deedeh, goshaayand-o ravand
Man bar dar-e to mogheem-e baadaam, cho khaak
Varnee, degaraan cho baad aayand-o ravand

◆

*in | alley of | you | the lovers | increase/grow/mature and | leave/go out*
*liver's blood (deep inner pain) | of | sight/eyes | they open (shed) and | leave*
*I | at | door of | you | stationary | eternal | like | earth/soil*
*although | others | like | the wind | come and | leave*

◆

The lovers crawl in and out of your alley,
They bathe in drips of blood; and not finding you, they give up and leave.
I am forever stationed at your door like the earth,
While others come and go like the wind.

742 AK

Shaahist ke, to har che bepooshi daanad
Beekaam, va zabaan gar bekhorooshi daanad
Har kas havas-e, sokhan-forooshi daanad
Man bandeye aanam, ke khamooshi daanad

*there is a king | who | you | what | ever | you wear/put on | he is aware of*
*without sound | and | tongue | if | you roar/scream | he is aware of*
*every | one | desire to | stand up and lecture | he is aware of*
*I | am the servant of | the one | who | silence | he is aware of*

There is a king who is aware of every mask you put on.
Whether you keep silent or wail, he is aware.
Everyone desires to stand up and lecture,
I am the servant of the one who honors silence.

745 UT

زنهار، مگوکه : ره روان نیز نیند
عیسی صفتان و بی نشان نیز نیند

زین گونه که تو محرم اسرار نه ؛
پنداشته که دیگران نیز نیند

◈

Zanhaar magoo ke, "Rah ravaan neez nee<u>and</u>
Eesaa sefataan, va beene<u>shaan</u> neez nee<u>and</u>"
Zeengoone, ke to mahram-e asraar na<u>ee</u>
Pendaash<u>te</u> ke, deegaraan neez nee<u>and</u>

◈

*alas | don't say | that | road/path | treaders | also | are not it*
*Jesus | followers | and | [those] of no sign | also | are not it*
*the same way | that | you | keeper of | secrets | are not*
*you think | that | others | also | are not it*

◈

Alas, don't say those treading the path are not the chosen ones,
That the followers of Christ, or the faithless are not the chosen ones—
Because you are not chosen to be the keeper of secrets,
You think that others are not the chosen ones.

750 UT

هر عمر که بی دیدن اصحاب بود
یا مرگ بود بطبع یا خواب بود

آبی که ترا تیره کند زهر بود
زهری که ترا صاف کند آب بود

Har om'r, ke bee deedan-e as'haab bood
Yaa marg bovad beta'b, yaa khaab bood
Aabee ke toraa teereh konad, zah'r bood
Zahree ke toraa saaf konad, aab bood

*any | lifetime | which | without | seeing | a master | it was*
*either | death | it was | in disguise | or | sleep | it was*
*the water | which | to you | dark | it does | poison | it was*
*the poison | which | to you | pure | it does | water | it was*

Any lifetime that is spent without seeing the master
Is either death in disguise or deep sleep.
The water that pollutes you is poison;
The poison that purifies you is water.

759 UT

گر در دل تنگ خود تو ماهی بینی
از من بشنو، که شمس تبریز بود

Labhaaye vey, aangah-ke be'esteez bood
Dar har do jahaan, azoo shekar reez bood
Gar dar del-e tang-e khod, to maahee beenee
Az man besheno, ke shams-e tabreez bood

*lips of | his | because | full of anger | it was (they were)*
*in | all | both | worlds | of him | sugar | rain/pour | it was (pouring down*
*sweetness)*
*if | in | heart of | small of | yours | you | a moon | you see*
*of | me | hear | that | Shams of | Tabriz | it was*

When his lips are full of anger
Sweetness rains down in the two worlds.
If you see a moon in the cave of your heart
Hear it from me, it is Shams-e Tabriz.

764 AK

عشق از ازلست و تا ابد خواهد بود

جوینده عشق بی عدد خواهد بود

فردا که قیامت آشکارا گردد

هر دل که نه عاشق است رد خواهد بود

◈

Eshgh, az azalast, va taa abad khaahad bood
Jooyandeye eshgh, bee'adad khaahad bood
Fardaa ke ghiyaamat, aashkaaraa gardad
Har del ke na aashegh ast, rad khaahad bood

◈

*love | is from | the infinite | and | until | eternity | it will | be*
*the seeker of | love | without a count/number (transcend time) | he will | be*
*tomorrow | when | resurrection | reveals | itself*
*any | heart | who | not | in love | is | fail/not pass | he will | be*

◈

Love is from the infinite, and will remain until eternity.
The seeker of love escapes the chains of birth and death.
Tomorrow, when resurrection comes,
The heart that is not in love will fail the test.

776 UT

احش گفتی، غلط مگو مہ چہ بود؟

شاہش گفتی، خطاست ہم شہ چہ بود؟

تا کی گویی مرا کہ: «بیگہ خیزی»؟

خورشید چو با منست، بیگہ چہ بود؟

*Maahash goftee, ghalat magoo mah che bood?*
*Shaahash goftee, khataast, ham shah che bood?*
*Taa kei gooyee maraa ke, "Beegah kheezee"*
*Khorsheed cho baamanast, beegah che bood?*

*moon he is | you said | mistake | don't say | moon | what | is*
*king he is | you said | wrong | this | king | what | is*
*till | when | you say | to me | that | untime/late | you get up*
*sun | because | is with me | untime/late | what | is*

You called Him a moon—you are mistaken. How can the moon compare?
You called Him a king—you are wrong. How can a king compare?
How often do you say, "You get up late."
When the Sun is with me, does time have any meaning?

779 AK

كامل صفتی راه فنا می پمود

چون باد گذر کرد در دریای وجود

یک موی ز هست او بر او باقی بود

آن موی بچشم فقر زنار نمود

Kaamel sefati, raah-e fanaa mipeimood
Chon baad gozar-kard, ze daryaaye vojood
Yekmooy ze hast-e oo, bar oo baaghee bood
Aan mooy becheshm-e fagh'r, zanaar nomood

*a perfect/complete | character one (a perfect being) | the path of | annihilation | was treading*
*like | the wind | he passed [quickly] | over | the sea of | life*
*one strand of hair | of | the being of | his | on | him | still left | it was*
*that | strand of hair | in the eyes of | poverty (detachment/glory of faith) | a non Moslem | it turned him*

A being of perfect character was treading the path of annihilation.
Like the wind, he swiftly crossed the ocean of existence.
But a single strand of worldly attachment remained.
In the eyes of poverty that one strand turned him into a non-believer.

785 AK

گر صبر کنم جامعهٔ جان میسوزد

جان من و آن جملگان میسوزد

ور بانگ برآورم دهان میسوزد

از من گذرد هر دو جهان میسوزد

◈

Gar sab'r konam, jaame'e jaan meesoozad
Jaan-e man-o, ann-jomlegaan meesoozad
Var baang bar-aavaram, dahaan meesoozad
Az man gozarad, har-do jahaan meesoozad

◈

*if | linger/wait | I do | all of | the soul | will burn*
*the soul of | mine and | all the others | will burn*
*if | cry/shout/scream | I do | the mouth | will burn*
*of | me | it will pass [through] | both | worlds | will burn*

◈

If I hesitate all of the soul will burn.
The soul of mine and all the others will burn.
If I scream the mouth will burn
It will pass through me and both worlds will burn.

788 UT

در عشق توام نصیحت و پند چه سود؟
زهراب چشیده ام مرا قند چه سود؟

گویند مرا که : « بند بر پاش نهید »
دیوانه دلست ، پام بر ، بند چه سود؟

Dar eshgh-e toam, naseehat-o pand chesood?
Zahraab chesheedeam, maraa ghand che-sood?
Gooyand maraa ke, "Band bar paash naheed"
Divaane del ast, paam bar band chesood?

*in | love of | you I am | advise and | words of wisdom | what use*
*poison | I have tasted | to me | sugar cubes | what use*
*they say | to me | that | string | on | his feet | place*
*crazy | heart | is | my feet | on | string | what use*

I am in love with you, what good is advice?
I have tasted poison, what good is sugar?
They say, "Fasten a rope around his feet."
It's the heart that is crazy, what good is in tying up my feet?

791 UT

*[Persian calligraphy]*

*[Persian calligraphy]*

❖

Bar goor-e man aankoo gozarad, mast shavad
Var eest konad, taa be'abad mast shavad
Dar bah'r ravad, bahr-o amad mast shavad
Dar khaak ravad, goor-o lahad mast shavad

❖

*on/around | grave of | mine | a person who | passes by | drunk | he will become*
*and if | stop | he does | until | eternity | drunk | he will become*
*in | sea | he goes | sea and | wet ground/shore | drunk | it will become*
*in | earth/ground | he goes | grave and | tomb | drunk | they will become*

❖

Any person passing by my grave will become drunk.
If he stops there, for eternity he will become drunk.
If he goes into the ocean, the ocean and the shore will become drunk.
If he goes into the grave, the tomb will become drunk.

800 UT

<div dir="rtl">

تا بنده زخود فانے مطلق نشود

توحید بنزد او محقق نشود ؛

توحید حلول نیست ، نابودن تست

ورنی بگزاف باطلی حق نشود

</div>

❖

Taa bandeh ze khod, faanie motlagh nashavad
Toheed benazd-e-oo, mohaghagh nashavad
Toheed halool neest, naaboodan-e tost
Varnee begazaaf, baatelee hagh nashavad

❖

until | a disciple | of | him self | annihilate of | the absolute | will not become
union | to him | reveal | will not become
union | penetrable | it is not | destruction of | you it is
otherwise | [even] in exorbitant | a worthless person | the truth | will not become

❖

Until a disciple annihilates himself completely,
Union will not be revealed to him.
Union can not be penetrated. It is your own destruction.
Otherwise, every worthless person would become the truth.

**805 UT**

بی عشق نشاط و طرب افزون نشود

بی عشق، وجود خوب و موزون نشود

صد قطره ز ابر اگر بدریا بارد

بی جنبش عشق دُر مکنون نشود

✦

Bee eshgh, neshaat-o tarab afzoon nashavad
Bee eshgh, vojood, khoob-o mo'zoon nashavad
Sad ghatreh ze ab'r, agar bedaryaa baarad
Bee jonbesh-e eshgh, dorr maknoon nashavad

✦

*without | love | joy and | festivity | increase | will not become*
*without | love | existence | good and | harmonious | will not become*
*hundred | drops | from | cloud | if | to the sea | rain down*
*without | the movement of | love | a pearl | hidden (in the sea) | will not become*

✦

Without love, there will be no joy and no festivity in the world.
Without love, there will be no true living and no harmony.
If a hundred raindrops pour down from the clouds to the sea
Without love's doing, a pearl will not form in the deepest waters.

806 AK

کی گفت که آن زندهٔ جاوید بمرد

کی گفت که آفتاب امید بمرد

آن دشمن خورشید در آمد بر بام

دو دیده ببست و گفت خورشید بمرد

Kee goft ke aan, zendeye jaaveed bemord
Kee goft ke, aaf<u>taa</u>b-e ommeed bemord
Aan doshman-e khor<u>shee</u>d, dar-aamad bar baam
Do deedeh bebast-o goft, khorsheed bemord

who | said | that | the one who | alive | eternal is | has died
who | said | that | the sun of | hope | has died
the | enemy of | the sun | has come | to the | roof top
both | eyes | he has closed and | said | the sun | has died

Who says that the immortal one has died? *
Who says that the Sun of hope has died?
Look, it is the enemy of the Sun who has come to the roof top!
Closing both eyes shut, crying, "O, the Sun has died!"
 *(Referring to the disappearance of Shams)*

809 AK

در حلقهٔ زلف او گرفتار بدیم
در گردن ما کمند دیگر آمد

ما بسته بدیم بند دیگر آمد
بیدل شده و نژند دیگر آمد

Maa baste bodeem, band-e digar aamad
Beedel shodeh-o, na<u>zhand</u>-e digar aamad
Dar halgheye zolfe oo, gereftaar bodeem
Dar gardan-e maa, kamand-e digar aamad

*I | tied up | I was | rope of | another | came*
*without heart | I became and | sorrow of | another | came*
*in the | curl of | hair of | he | caught | I was*
*around the | neck of | mine | lasso of | another | came*

I was all tied up yet another rope was added.
I had lost my heart to grief, yet another sorrow was added.
I was caught in the curl of His hair
Around my neck yet another band was added.

813 UT

امروز ز ما یار جنون می خواهد

ما مجنونیم او فزون می خواهد

گر نیست چنین، پرده چرا می درد

رسوا شده وز پرده برون می خواهد

◈

Emrooz zemaa yaar, jonoon meekhaahad
Maa majnooneem, oo fozoon meekhaahad
Gar neest cheneen, pardeh cheraa meedor'rad?
Rosvaa shodeh, vaz pardeh beroon meekhaahad

◈

*today | of me | the lover | madness | is asking*
*I | am mad | he | increase/even more | is asking*
*if | it is not | this way | curtain/veil | why | is he tearing open*
*disgrace | have become | and of | the curtain/veil | out | is asking*

◈

Today the Beloved is asking for madness.
I am already mad, yet He wants even more lunacy.
If this is not so, then why is He rending the veils?
I am disgraced already yet He wants it all revealed.

814 AK

Mardaan-e rahat, ke ser, ma'nee daanand
Az deedeye kootah-nazaraan, penhaanand
Een-<u>tor</u>fetar-aanke, har ke hagh-raa beshe<u>naa</u>kht
Mo'men shod-o, khalgh kaafarash mee<u>khaa</u>nand

*the men of | your path | who | secret | it's meaning | they know*
*of the | sight of | the narrow minded ones | they are hidden*
*more strange than this | any | one | [who] the truth | found/learned*
*a believer | he became | [but] the people | an infidel | they call him*

The men of the path who know the secrets of the unknown,
Are hidden from the sight of the narrow-minded ones.
Have you seen anything more strange? The ones who reach the truth
Become believers, but the people call them infidels.

824 AK

Ma'shoo<u>gh</u>eye khaanegi, bekaari naayad
Koo eshveh namaayad-o, vafaa nan<u>maa</u>yad
Ma'shogh-e kasee baayad, kaandar lab-e goor
Az baagh-e falak, hezaar dar bog<u>shaa</u>yad

*the mistress/lover of | the house | for any job | she is not good*
*for she | coquetry/tease | she does | faithful/devoted | she is not*
*the lover | a person | it should be | who | at the | tip of | the grave*
*from | the garden of | the sky | a thousand | door[s] | she will open*

The mistress of the house is good for nothing,
All she does is play foolish games.
The true mistress is the one who, when you are at the tip of the grave,
From the garden of the sky will open a thousand doors of the horizon.

840 AK

هان ای دل خسته وقت مرهم آمد

خوش خوش نفسی بزن که آندم آمد

یاری که از او کار شود یاران را

در صورت آدمی بعالم آمد

❖

Haan ey del-e khaste, vaght-e marham aamad
Khosh, khosh, nafasee bezan, ke aandam aamad
Yaarike az oo, kaar shavad yaaraanraa
Dar soorat-e aadami, be-aalam aamad

❖

*behold | O | heart of | tired | the time of | remedy | has come*
*sweet | sweet | a breath | you take | for | the [great] breath/moment | has come*
*the lover/companion who | of | him | work/help | it will be | to the lovers/*
*companions (he would help the men of God)*
*in the | face of/form of | a human being | to the world/universe | has come*

❖

Behold O tired heart, the relief has come.
Sweetly take a breath, for the great one has come.
The Lover, who takes care of the lover's needs,
In the form of a human being, to this world He has come.

842 AK

هر چند دلم رضای او میجوید
او از سر شمشیر سخن میگوید

خون از سر انگشت فرو میچکدش
او دست بخون من چرا میشوید

Har chand delam, rezaaye oo mijooyad
Oo az sar-e shamsheer, sokhan migooyad
Khoon az sar-e angosht, foroo michekadash
Oo dast bekhoon-e man, cheraa mishooyad

*the more | my heart | the approval of | him | it seeks*
*he | of | tip of | a sword | speak | he does*
*blood | of | tip of | [his] finger | down | it drops*
*he | hands | in blood | of mine | why | he is washing*

The more my heart seeks His approval,
The more He speaks with the sharp edge of a sword.
Look! There is blood dripping from His finger tips.
Why is He washing His hands in my blood?

844 UT

ای دل، اثر صبح، که شام که دید
یک عاشق صادق نکونام که دید

فریاد همی زنی، که من سوخته ام
فریاد مکن، سوختهٔ خام که دید

---

Ey del, asar-e sob'h, gah shaam kedeed
Yek aashegh-e saadegh-e nekoonaam, kedeed
Faryaad hameezanee, ke man sookhteam
Faryaad makon, sookhteye khaam, kedeed

---

*O | heart | the effect of | morning | when | night | who saw*
*a | lover who is | truthful | [with a] good name | who saw*
*cry out | you do | that | I | have burned*
*cry out | you should not | a burned | unbaked | who saw*

---

O heart, the morning glory in a dark night who has seen?
A true lover with a good reputation who has seen?
You cry out that I have burned
Cry not, a burned, still unbaked, who has seen?

861 AK

Yaaraan, yaaraan, ze ham jodaayee ma<u>ko</u>need
Dar sar, havas-e goreez paayee ma<u>ko</u>need
Chon jomle yeki'eed, do havaayee ma<u>ko</u>need
Farmood vafaa, ke biva<u>faa</u>yee ma<u>ko</u>need

*O friends/lovers | O lovers | of | each other | separation | don't do*
*in | the head | the desire of | escaping | feet | don't do*
*since | all of you | are one | (having) two | fantasies | don't do*
*proclaimed | devotion | that | without devotion (indifference) | don't be*

O lovers, don't keep away from each other.
Let go of the thoughts of escaping the flock.
You are all one, don't nourish the illusion of duality.
Devotion has proclaimed this, "Don't live without me."

876 AK

ای خاک درت ز آب کوثر خوشتر

اندر ره تو پای من از سر خوشتر

چون بانگ دف عشق ترا ماه شنید

مه گشت دو تا و گفت چنبر خوشتر

◈

Ey khaak-e darat, ze aab-e kosar khoshtar
Andar rah-e to, paaye man az sar khoshtar
Chon baang-e daf-e eshgh-e toraa, maah sheneed
Mah gasht dotaav-o, goft chanbar khoshtar

◈

*O | the dust of | your door | of | the water of | Kosar (a heavenly river) | more
pleasant/better
on | the path of | yours | feet of | mine | of | [my] head | more pleasant/ better
when | the sound of | the frame drum of | love of | yours | moon | heard
moon | became | two and | said | orbiting | more pleasant/better*

◈

The dust of your door from the water of Kosar is more pleasant.
On your path, my feet from my head, are more pleasant.
When the sound of the drum of your love was heard by the moon
The moon became two and said, "This way orbiting is more pleasant."

882 AK

ای مرد سماع معده را خالی دار

زیرا چو تهی ست نی کند ناله زار

چون پر کردی شکم ز لوت بسیار

خالی مانی ز دلبر و بوس و کنار

---

Ey mard-e samaa', me'deraa khaalee daar
Zeeraa cho toheest, ney konad naaleye zaar
Chon por kardee, shekam ze loot besiyaar
Khaalee maani, ze delbar-o boos-o-kenaar

---

*O | man of | samaa | stomach | empty | keep*
*because | since | it is empty | ney (reed flute) | does | cry of | bitter*
*when | full | you do | your belly | of | viands-pastry | too much*
*empty/deprived | you will be | of | the lover | kisses and all*

---

O man of samaa, keep your stomach empty.
The ney cries so bitterly because it is empty inside.
When you fill your belly with too much pastry
Then you will be deprived of the Lover, His kisses, and all.

900 AK

خاک و شــدم یار موافق حتا
ازخون برادر منـافق بهتـه

دورسے زبرادر منافق بهتـه
پرهیـــنرزیار ناموافق بهتـه

❖

Dooree ze baraadar-e monaa<u>fegh</u>, behtar
Parheez, ze yaar-e namo<u>vaa</u>fegh, behtar
Khaak-e ghadam-e yaar-e movaa<u>fegh</u>, hagh'aa
Az khoon-e baraadar-e monaa<u>fegh</u>, behtar

❖

*being faraway | from | a brother who is | hypocritical | is better*
*keeping away | from | the lover who is | not agreeing | is better*
*the dust of | the step of | the lover | who is agreeable | is the truth*
*of | [sharing the same] blood as | the brother who is | hypocritical | is better*

❖

Being far away from a hypocritical brother is better.
Keeping away from a disagreeable lover is better.
The dust of the feet of the agreeable lover is the Truth,
And of the blood of the hypocritical brother it is better.

906 AK

---

Tab'am cho hayaat yaaft, az jelveye zek'r
Aavard aroos-e nazm, dar hojreye fek'r
Dar har beity, hezaar dokhtar benemood
Har yek bemesaal-e maryam, aabestan-o bek'r

---

*my gift of poetry | when | life | it found | because of | the glow of | zek'r (repetition of the name of God)*
*it brought | the bride (goddess) of | poetry | in the | house of | the mind*
*in | every | verse | a thousand | girl[s] | it placed/created*
*every | one | similar to | Mary | pregnant and | [still] a virgin*

---

When my poetic nature found life through the repetition of God's name,
The goddess of poetry entered the house of the mind.
It created a thousand maidens in every verse
Every one, pure like Mary, pregnant yet still a virgin.

907 AK

فرمود خــدابوحی کای پیغمبر

جز در صف عاشقان منشین مگذر

هر چند زر آتشت جهان گرم شود

آتش میرد ز صحبت خاکستر

Farmood khodaa bevah'y, kai pei<u>gh</u>ambar
Joz dar saf-e aasheghaan, be<u>man</u>sheen magozar
Har-chand ze aatashat, jahaan garm shavad
Aatash meerad, ze sohbat-e khaakestar

*proclaimed | God | in divine inspiration | that O | Prophet/messenger*
*except | in the | queue/line/path of | the lovers | don't sit | don't pass by*
*although | of | your fire/flame | the world | warm | it becomes*
*the fire/flame | dies | of | the talk of | the ash*

God revealed to the Prophet a divine inspiration.
He said, "Don't settle, don't tread except in the alley of the lovers."
It may be that the universe is warmed by your flame
But listen, while speaking of the ash the fire dies away.

910 AK

گر گل کارم بی تو نزوید جز خار
ور بیضهٔ طاوس نهم هم گردد مار

در برگیرم رباب بردارد تار
ور هشت بهشت برزنم گردد نار

❖

Gar gol kaaram beeto, narooyad joz khaar
Var beizeye taavoos naham, gardad maar
Dar bar geeram robaab, bardarad taar
Var hasht behesht barzanam, gardad naar

❖

*if | flower/rose | I plant | without you | won't grow | but | thorn*
*if | the egg of | peacock | I place | will become | a snake*
*in | my arms | I hold | a rubaab (an instrument) | will play | tar (lute)*
*and if | [in the] eight | heaven | I play | will become | in flames*

❖

Without you, I plant roses, yet only thorns grow.
A snake comes out of the peacock's egg.
I hold a rubaab, it sounds like a tar.
And if I play it, even the eight heavens will burn in flames.

912 AK

Goftam, "Cheshmam" Goft, "Beraa<u>hash</u>-meedaar"
Goftam, "Jegaram" Goft, "Paraa<u>hash</u>-meedaar"
Goftam ke, "Delam" Goft, "Che daaree dar del?"
Goftam, "Gham-e to" Goft, "Negaa<u>hash</u>-meedaar"

*I said | my eyes | he said | on his way keep them*
*I said | my liver/guts | he said | tear it apart*
*I said | that | my heart | he said | what | do you have | in | heart*
*I said | sorrow of | you | he said | keep it*

I said, "My eyes." He said, "Focus them on his path of arrival."
I said, "My guts." He said, "Tear them open."
I said, "My heart." He said, "What do you have in your heart?"
I said, "Your sorrow." He said, "Keep it."

925 AK

 هر دم دل خسته ام برنجاند یار
یا سنگدلست یا نمیداند یار

بر چهره ام نوشته ام بخون قصه دل
می بیند و هیچ بر نمی خواند یار

◈

Har dam del-e khaste'am, beranjaanad yaar
Yaa sangdelast, yaa nemidaanad yaar
Bar chehreh neveshte'am, bekhoon gheseye del
Meebinad-o, heech bar-nemeekhaanad yaar

◈

*every | breath/moment | heart of | tired of mine | torchers | the Beloved*
*either | he is stone hearted | or | he is not aware | the Beloved*
*on | the face | I have written | in blood | the saga | of the heart*
*he sees and | at all | he doesn't read it | the Beloved*

◈

With every breath comes a new ache from the Beloved.
Either He is stone-hearted or not aware of my pain.
I have written the saga of the heart on my forehead, in blood,
He sees it, yet He doesn't seem to be reading it.

930 UT

Goftam, "Benamaa ke choon konam" Goft, "Bemeer"
Goftam ke, "Shod aab roghanam" Goft, "Bemeer"
Goftam ke, "Shavam sham', man parvaane
Ey rooye to, sham'e roshanam" Goft, "Bemeer"

I said | you reveal | that | what | I do | he said | die
I said | that | became | water | my oil (I am losing substance-purifying) | he said | die
I said | that | I'll become | a candle | I | a butterfly
O | face of | you | candle of | my bright | He said | die

I said, "Tell me what to do?" He said, "Die."
I said, "I am becoming lighter, impurities are vanishing." He said, "Die."
I said, "I'll become a candle, a butterfly,
O Your face, is my bright candle." He said, "Die."

936 AK

<div dir="rtl">

ای دل همه رخت را در این کوی انداز

پیراهن یوسف است بر روی انداز

ماهی بچه‌ای عمر نداری بی آب

اندیشه مکن خویش در این جوی انداز

</div>

❖

Eydel hame rakhtraa, dar een kooy andaaz
Piraahan-e yoosef ast, bar rooy andaaz
Maahi-bache'i, omr nadaari bi-aab
Andishe makon, kheesh dar-in jooy andaaz

❖

*O heart | all | [your] clothing | in | this | alley | you throw*
*the shirt of | Joseph | it is | on | your face/self | you throw*
*a small/baby fish you are | life | you don't have | with out water*
*think | not | yourself | in this | stream | you throw*

❖

O heart, let go of all your clothes and throw them on this path.
Think of it as the shirt of Joseph, let it cover your face.
You are a small fish, you have no life without water.
Don't think, just throw yourself into this stream.

942 AK

ای لاله بیا و از رخم رنگ آموز

وی زهره بیا و از دلم چنگ آموز

وآنگه که نوای وصل آهنگ کند

ای بخت ابد بیا و آهنگ کند

Ey laale biyaav-o, az rokham rang aamooz
Vey zohreh biyaav-o, az delam chang aamooz
Vaangah-ke navaaye vasl, aahang konad
Ey bakht-e abad, biyaav-o aahang aamooz

O | tulip | come and | from | my face | [fine] color | learn
and O | Venus | come and | from | my heart | [sound of] harp | learn
when | the [inner] sound of | union | its tune/song | it plays
O | destiny of | eternal | come and | its tune/song | learn

O tulip, come and learn from my face the vibrancy of color.
And O Venus, come and learn from my heart the sound of the harp.
When the inner sound of union plays its song,
O eternal fate, come and learn its sweet melody.

953 AK

دل آمد و گفت هست سودا ش دراز
شب آمد و گفت زلف زیبا ش دراز

سرو آمد و گفت قد و بالا ش دراز
او عمر عزیز ماست گو باش دراز

◈

Del aamad-o goft, hast sodaash deraaz
Shab aamad-o goft, zolf-e zibaash deraaz
Sarv aamad-o goft, ghadd-o baalaash deraaz
Oo omr-e aziz-e maast, goo baash deraaz

◈

*heart | came and | said | is | his passion | long/tall*
*night | came and | said | the hair of | beautiful of his | [is] long/tall*
*cypress | came and | said | his height and | stature of his | [is] long/tall*
*he | the life of | sweet of | mine is | tell him | remain | long/tall*

◈

Heart said, "His path of passion is long."
Night said, "His dark, beautiful hair is long."
Cypress said, "His height and stature are long."
He is my sweet life, tell Him to remain long.

956 UT

شب گشت ومرانیت خبر از شب وروز
روزاست شبم، زروی آن روزافروز

ای شب، شب از آنی که از وبی خبری
ای روز، برو، زروز او، روز آموز

◈

Shab gasht-o maraa ·neest khabar, az shab-o rooz
Roozast shabam, ze rooye aan rooz afrooz
Ey shab, shab az aanee ke az oo bee<u>khabar</u>ee
Ey rooz, boro, ze rooz-e oo, rooz aamooz

◈

*night | it turned and | for me | there is no | news | of | night and | day*
*day is | my night | of | face of | that | day | burner (bright daylight)*
*O night | night | of | that you are | because | of | him | you have no news*
*O day | go | of | day of | him | day | learn*

◈

It's turned night and I have no news of night and day.
Seeing His sun-like face, my nights have become bright like days.
O night, you are dark because you are ignorant of His glory
O daylight, go and learn from Him what it means to shine.

968 UT

<div dir="rtl">

بازآمدم اینک، که زنم آتش تیز

در توبه و در گناه و جرم و پرهیز

آوردم آتشی، که همی فریاد

کای هرچه جز از خداست از ره برخیز

</div>

Baaz aamadam eenak, ke zanam aatash-e teez
Dar tobeo, dar gonaaho jorm-o parheez
Aavardam aatashee, ke meefarmaayad
Kei harche joz az khodaast, az rah barkheez

*once more | I have come | now | that | to strike | fire of | blazing*
*in | repentance and | in | sin and | crime and | restriction/discrimination*
*I have brought | a fire | that | is proclaiming*
*that O | anything | except | of | God | of | path | rise up (leave)*

I have come again to set a blazing fire
To repentance, sin, crime, and discrimination.
I have brought a flame which is proclaiming
"Anything that is not of God, depart from the path."

977 AK

ازحادثه جهان زاینده مترس
وز هرچه رسد چو نیست پاینده مترس

این یکدم عمر را غنیمت می‌دان
از رفته میندیش وز آینده مترس

◈

Az haadeseye, jahaan-e zaayand-e matars
Vaz harch-e resad, cho neest paayandeh matars
In yekdam-e omr'raa, ghanimat-midaan
Az rafte miyandish, vaz aayandeh matars

◈

*of the | incidents of | the world of | paternal (producing offsprings) | don't be afraid*
*and of | anything | that is received/coming to you | because | it is not | everlasting | don't be afraid*
*this | one breath of | life | you make the most of*
*of | [what is] gone | don't think | and of | the future | don't be afraid*

◈

Of the games of this evolving world, don't be afraid.
Of what is coming to you, whatever your fortune, don't be afraid.
Make the most of this single breath called life.
Don't think of what is gone, and of the future don't be afraid.

978 AK

از روز قیامت جهان سوز بترس
وز ناوک انتقام دلدوز بترس
ای در شب حرص خفته در خواب غرور
صبح اجلت رسید از روز بترس

---

Az rooz-e ghiyaa<u>mat</u>-e jahaan sooz, betars
Vaz naavak-e enteghaam-e deldooz, betars
Ey dar shab-e hers, khofte dar khaab-e ghoroor
Sobh-e ajalat resid, az rooz betars

---

*of | the day of | resurrection of | world | burning | be fearful*
*and of | small arrow of | revenge of | heart stitching | be fearful*
*O | in the | night of | greed | asleep | in the | dream of | arrogance*
*the morning of | your death | has come | of | the day | be fearful*

---

Be fearful of the world-burning day of resurrection.
Be fearful of the heart-piercing arrow of revenge.
O, in the night of greed, asleep, lost in the dream of arrogance,
Be fearful of the day—the morning of your death has come.

985 AK

روم کب عشق را قوی ران ومترس

وز مصحف کر آیت حق خوان ومترس

چون از خود و غیر خود مسلم گشتی

معشوق تو هم توی یقین دان ومترس

❖

Ro markab-e eshghraa, ghaviraan-o matars
Vaz mosahaf-e kazh, aayat-e hagh khaan-o matars
Chon az khod-o gheir-e khod, mosallam gashti
Ma'shoogh-e to ham to'i, yagheen-daan-o matars

❖

*go | the saddle of | love | strongly (with determination) ride and | don't be afraid
and | the misspelled [words] | [and] crooked | verse | in truth | you read and |
don't be afraid
because of | yours (your kind) and | not of yours | convinced | you became
the lover for | you | is also | you | be assure [of that] and | don't be afraid*

❖

Go and ride the saddle of love with determination—don't be afraid.
Read the misspelled holy verses in their true form and don't be afraid.
Now that you are convinced of your natural place in life,
Learn this: your lover is none other than you, don't be afraid.

986 AK

Rooyam cho zar-e zamaane, meebin-o mapors
In ashk cho naardaane, meebin-o mapors
Ahvaal-e daroon-e khaane, az man matalab
Khoon bar dar-e aastaane, meebin-o mapors

*my face | like | gold of | the times | see | and don't ask*
*this | tear drop | like | pomegranate seeds | see | and don't ask*
*the condition of | inside the | house | of | me | don't ask/request*
*blood | at the | door of | threshold | see | and don't ask*

See this face, sallow as gold—don't ask why.
See these tear drops, like seeds of a pomegranate—don't ask why.
Don't bother me with the inside condition of my house
See the blood at the threshold and don't ask why.

988 AK

عاشق چو نمی شوی برو پشم بریس
صدکاری و صدرنگی و صدپیشه وپیس

درکاسه سر چو نیست ش باده عشق
درمطبخ مدخلان برو کاسه لیس

❖

Aashegh cho nemishavi, boro pashm beris
Sad kaari-o, sad rangi-o, sad pishe-o-pees
Dar kaaseye-sar, cho neestat baadeye eshgh
Dar matbakh-e moda<u>kh</u>elaan, boro kaase belees

❖

*a lover | since | you don't become | go | wool | spin*
*a hundred | work/craft and | a hundred | color/types and | a hundred professions*
*(go and do instead)*
*in the | skull | since | [for you] there is no | wine of | love*
*in the | kitchen of | those who have entered/companions | go | a bowl | you lick*

❖

Since you are not a lover, go and spin wool instead.
Go and do a hundred works of a hundred types in a hundred professions.
If there is no wine of love in your skull
Then go and lick the bowls in the kitchen of lovers.

996 AK

آن رند و قلندر نهان آمد فاش

در دیدهٔ من بجو نشان کف پاش

یا اوست خدا یا فرستاده خداش

ای مطرب جان یک نفسی با ما باش

❖

Aan rend-o ghalandar-e nahaan, aamad faash
Dar deedeye man, bejoo neshaan-e kaf-e paash
Yaa oost khodaa, yaa ke ferestaadeh khodaash
Ey motreb-e jaan, yek nafasee baa maa baash

❖

*that | scondrel and | mendicant of | the hidden | became | revealed*
*in the | sight/eyes/face of | mine | seek | the trace of | bottom of | his feet*
*either | he is | God | or | that | he has been sent | by God*
*O | the musician of | soul | [for] one | breath | with | me | stay*

❖

That hidden mendicant has been revealed.
Seek traces of his feet in the light of my eyes.
He is God or he has been sent by God.
O the musician of the soul, stay with me for one breath.

1004 UT

اى عشق هيا، به تلخ خويان خو بخش

اى پشت جهان، به حسن جويان رو بخش

از باغ جمال تو چه کم خواهد شد

زان سيب زنخدان، دو سه شفتالو بخش

🔷

Ey eshgh, beeyaa, betalkh khooyaan khoo bakhsh
Ey posht-e jahaan, behosn jooyaan roo bakhsh
Az baagh-e jamaal-e to, che kam khaahad-shod?
Zaan seeb-e zenakhdaan, do se shaftaaloo bakhsh

🔷

O | love | come | to the sour | disposition/natured ones | disposition | you give in honor
O | back [bone] of | the world | to goodness | those who are seeking | kindness/attention | you give in honor
of | garden of | face of | you | what | less | it will become
of that | apple of | the chin | two | three | peaches | give in honor

🔷

O love, transform the character of these sour people.
O backbone of the world, show kindness to the seekers of beauty.
Will it become less the garden of your face,
If from the apple of your chin, you offer two or three peaches?

1012 UT

Dar anjomanee, neshaste deedam dooshash
Natavaanestam gereft, dar aaghooshash
Rokhraa bebahaane, bar rokhash benhaadam
Ya'nee ke, hadees meekonam dar gooshash

in | a gathering | seated | I saw | him last night
I could not | hold [him] | in | my arms
my face | as an excuse | next to | his face | I placed
it means | that | holy discourse | I am saying | in | his ear

Last night I saw him seated in a gathering.
I could not hold him in my arms,
So I placed my face near His, as an excuse,
As if I were whispering some holy words in his ear.

1012 AK

ای دل برو از عاقبت اندیشان باش

در عالم بیگانگی از خویشان باش

گر باد صبا مرکب خود می خواهی

خاک قدم مرکب درویشان باش

Ey del boro, az aaghebat-andee<u>shaa</u>n baash
Dar aalam-e bee<u>gaa</u>negi, az kheeshaan baash
Gar baad-e sabaa, markab-e khod mikhaahee
Khaak-e ghadam-e markab-e, darveeshaan baash

*O | heart | go | of | those who are concerned with consequences | become*
*in the | world of | alienation | of | one of us | become*
*if | the breeze of | dawn | the mount/horse of | yourself | you desire*
*the dust of | step/feet of | the horse/mount of | the darvishes | become*

O heart, do worry about your destiny.
In this world of alienation, come and join our gathering.
If you desire to mount the breeze-of-dawn and ride into eternity
Then become the dust of the feet of the horse of a darvish.

1019 UT

که باده لقب نهادم، وکه جامش

گاهی زرِ پخته، گاه سیمِ خامش

که دانه، وگاه صید، وگاهی دامش

این جمله چراست؟ تا نگویم نامش

<hr/>

Gah baadeh laghab nahaadam, va gah jaamash
Gaahee zar-e pokhte, gaah seem-e khaamash
Gah daane, vo gaah seid-o, gaahee daamash
Eenjomle cheraast? Taa nagooyam naamash

<hr/>

*at times | wine | name | I called/placed | and | at times | him a cup*
*some times | gold that is | baked | at times | silver that is | unbaked*
*at times | a seed | and | at times | prey and | sometimes | a trap*
*all this | is a question/mystery | until | I don't say | his name*

<hr/>

At times I called Him wine, at times a cup.
At times a polished gold, at times a rough silver.
At times a seed, at times a prey, and sometimes a trap.
All this a mystery until I reveal His name.

1026 UT

گفتی: « چونی؟ » بیا که چون روزم خوش

چون روز همیشه درّم و می دوزم خوش

تا روی چو آتشت بدیدم، چو سپند

می سوزم، و می سوزم، و می سوزم خوش

Goftee, "Chonee?" Biyaa ke chon roozam khosh
Chon rooz, hamee dar'ram-o meedoozam khosh
Taa rooye cho aatashat bedeedam, cho sepand
Meesoozam-o, meesoozam-o, meesoozam khosh

*you said | how are you | come | because | like | day I am | happy/joyful*
*like | day | continuously | I am tearing apart and | I am sewing back |*
*happy[happily] (referring to dawn and dusk)*
*until | face of | like | fire of yours | I saw | like a | wild rue (incense)*
*I am burning | I am burning | I am burning | happy[happily]*

You said, "How are you?" Come, for I am as happy as daylight.
Like day, I bring an end to myself, and in joy I start all over again.
When I saw your fiery face I became like wild rue
Burning in your flames, burning, I am burning so joyfully.

1028 AK

شو پیوسته مرید حق شو و باقی باش

مستغرق عشق و شور و مشتاقی باش

چون باده بجوش در خم قالب خویش

وانگاه بخود حریف و هم ساقی باش

Peyvaste moreed-e hagh sho vo, baaghi baash
Mosta<u>gh</u>regh-e eshgh-o, shoor-o, mosh<u>taa</u>ghee baash
Chon baadeh bejoosh, dar khom-e ghaaleb-e kheesh
Vaangaah bekhod, hareef-o ham saaghi baash

*constantly | the disciple of | the truth | become | and | ever last | become*
*drowned in | love and | excitement and | amorous anxiety | become*
*like | the wine | boil | in the | barrel of | mould of | yourself*
*then | to yourself | a companion and | also | Saaghi (the cupbearer) | become*

Constantly serve the truth and you will become eternal.
Lose yourself in excitement and the frenzy of true love.
Boil like the wine in the barrel of your body
Then see yourself becoming the divine companion and the Saaghi.

1035 UT

بایرِخردونهفته می گفتم دوش

کزمن سخن سّرجهان هیچ مپوش

نرمک نرمک مرا همے گفت بگوش

کین دیدنیست، گفتنے نیست خموش

⧈

Baa peer-e kherad, nahofte meegoftam doosh
Ke: "Ze man sokhan-e ser'r-e jahaan, heech mapoosh"
Narmak narmak, maraa hamee goft begoosh
"Keen deedaneest, goftanee neest khamoosh"

⧈

*with | the master of | knowledge | in hiding | I was talking | last night*
*that | of | me | words of | secret of | the world | at all | don't cover/keep away*
*slowly | slowly | to me | like this | he said | in the ear*
*that this | is to be seen | to be talked about | it is not | be silent*

⧈

Last night in retreat I was talking to the master of knowledge.
I said, "Please don't keep the secrets of the world from me."
Ever so gracefully he whispered in my ear,
"This is something to be seen, not to be talked about. Be silent."

1046 UT

امروزسماعت وسماعت وسماع
نورست وشعاعت وشعاعت وشعاع

این عشق، مشاعت ومشاعت ومشاع
از عقل وداعت وو داعت و وداع

◈

Emrooz samaa'ast-o, samaa'ast-o, samaa
Noorast-o shoaa'ast-o, shoaa'ast-o, shoaa
Een eshgh, moshaa'ast-o, moshaa'ast-o, moshaa
Az agh'l vedaa'ast-o, vedaa'ast-o vedaa

◈

*today | it is samaa and | it is samaa and | samaa*
*it is light and | it is illumination and | it is illumination and | illumination*
*this | love | it is unifying | it is unifying | unifying*
*of | intellect | it is bidding farewell and | it is bidding farewell and | farewell*

◈

Today it's time for samaa, for samaa, for samaa.
Today is bright and illuminating, illuminating, illuminating.
This love is unifying, unifying, unifying.
And it's bidding the intellect farewell, farewell, farewell.

1055 AK

بلبل آمد بباغ ورستیم زراغ

آئیم بباغ باتو ای چشم وچراغ

چون سوسن وگل زخویش بیرون آئیم

چون آب روان رویم ازباغ بباغ

❖

Bolbol aamad bebaagh-o, rosteem ze zaagh
Aayim bebaagh baa to, ey cheshm-o cheraagh
Chon soosan-o gol, ze kheesh biroon aayim
Chon aab-e ravaan, raveem az baagh be baagh

❖

*the nightingale | came | to the garden and | we escaped | of the | raven*
*we come | to the garden | with | you | O | eyes and | the light*
*like | lily and | a flower/rose | of | ourselves | out | we come*
*like | water | flowing | we go | from | garden | to | garden*

❖

The nightingale came to the garden, so we can escape the raven.
It is you who brings us to the garden. O light of our eyes.
Like a lily, we open up and unravel from ourselves.
Like a flowing stream, we go from one garden to the next.

1070 UT

Dar bahr-e safaa, godaakhtam hamcho namak
Nee kofr-o na eemaan, na yagheen maand-o na shak
Andar deleman, setaare'i peidaa shod
Gom gasht dar aan setaareh, har haft falak

in the | waters of | purity | I melted | like | salt
neither | blasphemy | nor | faith | nor | conviction | remained | nor | doubt
in the middle | of my heart | a star | appeared | it has
lost | have became | in | that | star | all | seven | heavens

In the waters of purity, I melted like salt
Neither blasphemy, nor faith, nor conviction, nor doubt remained.
In the center of my heart a star has appeared
And all the seven heavens have become lost in it.

یکچند میان خلق کردیم درنگ

زایشان بوفانه بوی دیدیم نه رنگ

آن به که نهان شویم از دیدهٔ خلق

چون آب در آهن و چو آتش در سنگ

---

Yekchand miyaan-e khalgh, kardeem derang
Ze-ishaan bevafaa, na booy dideem na rang
Aan beh ke nahaan shaveem, az dideye khalgh
Chon aab dar aahan-o, cho aatash dar sang

---

*for a while | amongst the | people/masses | we did | pause/temporarily stayed*
*of them | faithfully/in truth | neither | a smell | we saw | nor | a color (referring to
human qualities, ie; kindness, generosity)*
*it is | better | that | hidden | I become | of | the sight of | the people*
*like | water | in | iron and | like | fire | in | stone*

---

For a while I lived amongst the people,
Never truly sensing the smell of graciousness, the color of kindness.
It is better that I hide myself again,
Like water in iron, like fire in stone.

1083 UT

این عشق کمالست و کمالست و کمال

این نفس خیالست و خیالست و خیال

این نور جلالست و جلالست و جلال

امروز وصالست، وصالست و صال

---

Een eshgh kamaa<u>last</u>-o, kamaa<u>last</u>-o, kamaal
Vin nafs khiyaa<u>last</u>-o, khiyaa<u>last</u>-o, khiyaal
In noor jalaa<u>last</u>-o, jalaa<u>last</u>-o, jalaal
Emrooz vesaa<u>last</u>-o, vesaa<u>last</u>-o, vesaal

---

*this | love | is perfection and | is perfection and | perfect
and the | passions | are imaginary and | are imaginary and | imaginary
this | light | is the glory and | is the glory and | the glory
this day | is unifying and | is unifying and | unifying*

---

This love is perfection, perfection, perfection.
The passions are imaginary, imaginary, imaginary.
This light is full of glory, glory, glory.
This is the day of unity, unity, unity.

1088 AK

اسرار حقــیقت نشود حل بسُوال

نی نیـــز بدر باختن جشمت و مال

تا دیده و دل خون نشود پنجـ سال

از قال کسے را نبود راہ بحال

❖

Asraar-e haghighat, nashavad hal beso'aal
Nee-neez bedar-baakhtan-e, heshmat-o maal
Taa didev-o del, khoon nashavad panje saal
Az ghaal kaseeraa nabovad, raah behaal

❖

*mysteries of | the truth | will not be | solved | with questioning*
*nor | losing one's | retinue and | properties*
*until | the sight/eyes and | the heart | bloody | they don't become | for five | years*
*from | discourse/sermon | any one | will not have access to | the path | of divine*
*intoxication*

❖

Questioning will not reveal the mysteries of the truth,
Nor giving away one's goods and properties.
Unless the vision and the heart have suffered five years of bloody torment
From mere chatter, no one will walk on the path of selflessness.

1089 UT

خود ممکن آن نیست که بردارم دل
آن به که بسودای تو بسپارم دل

گر من به غم عشق تو نسپارم دل
دل را چه کنم؟ بهر چرا دارم دل

---

Khod momken-e-aan neest, ke bardaaram del
Aanbeh, ke be sodaaye to, bespaaram del
Gar man be gham-e eshgh-e to, naspaaram del
Delraa che konam? Bahre-cheraa daaram del?

---

*my self | the possibility | there is not | to | take out | the heart*
*it is better | that | to | passion of | you | I give in trust | the heart*
*if | I | to | grief/sorrow of | love of | you | don't give in trust | the heart*
*the heart | what | can I do | for what purpose | I have | the heart*

---

I have no choice but to remove my heart.
Yet I would rather offer it to the passion of your love.
If I don't offer my heart to the sorrow of your love
What do I need it for? What other purpose can it serve?

1091 UT

ازمن زر و دل خواستی ای ے مہر گسل

حقا کہ نہ این دارم و سے نے آن حاصل

زرکو؟ زر کی؟ زر از کجا؟ مفلس و زر؟

دل کو؟ دل کی؟ دل از کجا؟ عاشق و دل؟

Az man zar-o del khaastee, ey meh'r gosel
Haghaa-ke na een daaram-o, nee aan haasel
Zar koo? Zar kei? Zar az kojaa? Mofles-o zar?
Del koo? Del kei? Del az kojaa? Aa<u>sh</u>egh-o del?

*of | me | gold and | heart | you have asked | O | affection | breaker*
*in truth | neither | this | I have and | nor | that | is possible*
*gold | where | gold | when | gold | of | what place | a poor man and | gold*
*heart | where | heart | when | heart | of | what place | a lover and | heart*

You have asked of me gold and heart, O heart-breaker.
Truly, I have neither this, nor is the other possible.
What gold? When gold? From where gold? A poor man and gold?
What heart? When heart? From where heart? A lover and heart?

1091 AK

*[Persian calligraphy]*

پر از عیسی است این جهان مالامال

کی گنجد در جهان قماش دجال

شورابه بلخ تیره دل کی گنجد

چون مشک جهان پر است از آب زلال

---

Por az eesaa ast, een jahaan maalaamaal
Kei gonjad dar jahaan, ghomaash-e dojaal
Shoo<u>raa</u>beye talkh-e teereh del, kojaa gonjad
Chon moshk-e jahaan, por ast az aab-e zolaal

---

*full | of | Jesus | is | this | world | to the brim (teeming)*
*where | can fit | in the | world | garb of | the Anti-Christ*
*bitter juice of | sour of | a dark | heart | where | can it fit*
*when | the sack of | the world | full | is | of | water of | pure/clear*

---

This world is teeming with the presence of Christ
Where then can the garb of an Anti-Christ fit?
Where can fit the bitter juice of a dark heart
When the sack of the world is bursting with crystalline water?

1099 AK

عشقی بکمال و دلرباییے بجمال

دل پر سخن و زبان ز گفتن شده لال

زین نادره تر کجا بود هرگز حال

من تشنه و پیش من روان آب زلال

Eshghi bekamaal-o, del<u>r</u>obaa'ee bejamaal
Del por sokhan-o, zabaan ze goftan shodeh laal
Zeen naadereh tar, kojaa bovad hargez haal
Man teshnev-o, peesh-e man ravaan aab-e zolaal

*a love | that is perfect and | stealing of the heart | through | beauty*
*heart | full of | words and | tongue | of | speaking | has become | mute*
*of this | rarity | more | where | it will be | ever | a circumstance*
*I | am thirsty and | next to | me | flows | water of | pure*

A perfect love and a heart-stealer of such beauty.
A heart full of words and the tongue a wordless mute.
Have you heard a legend as rare as this?
Dying of thirst and next to me flows crystalline water.

1106 UT

<div dir="rtl">

هر چیز که آن خوشت نهیست مدام

تا می نشود دلیل این مردم عام

ورنه می و چنگ و صورت خوب و سماع

بر خاص حلال گشت و بر عام حرام

</div>

Har cheez ke aan-khoshast, nahi-ast modaam
Taa minashavad daleel, in mardom-e aam
Varna, mey-o chang-o, soorat-e-khoob-o samaa
Bar khaas halaal gasht-o, bar aam haraam

*any | thing | that | is pleasant | is prohibited | continually*
*until | not give | an example/reason/guide | to these people in | general*
*otherwise | wine and | harp and | a beautiful face and | samaa (whirling)*
*for the | elite | admissible | became and | for the | public | unlawful*

Whatever is pleasant is always prohibited
So the public would not have a chance to try them.
Wine, harp, a beautiful face, and samaa
Is admissible for the elite, it is unlawful to the public.

1135 UT

چون مار ز افسون کسے می پیچم

چون طرهٔ جعد یار پیچاپیچم؛

واللہ کہ ندانم این چہ پیچاپیچیت؛

این میدانم کہ چون نپیچم هیچم

❖

Chon maar, ze afsoon-e kasee meepicham
Chon tar'reye ja'd-e yaar, peechaapicham
Vaallaah ke, nadaanam een che peechaapicheest
Een meedaanam ke, chon napeecham hicham

❖

*like | a snake | of | spell of | some one | I am twisting and winding*
*like | string of | lock of hair of | the Beloved | I am twisting and winding*
*swear to God | that | I do not know | this | what | kind of twisting and*
*winding it is*
*this | I know | that | if | I don't twist/wind/turn | I am nothing*

❖

Like a snake, spellbound, I am twisting and winding.
Like a strand of the Beloved's hair, I am twisting and winding.
I swear, I have no idea what kind of twisting and winding this is,
I know this, if I don't twist and wind, I do not exist.

1135 AK

از صنع برآیم بر صانع باشم
حاشا که زبون هیچ مانع باشم

چون مطبخ حق زلوت مالامال است
تا چند به آب گرم قانع باشم

Az san' bar-aayam, barsaane baasham
Haashaa ke zaboon, heech maane baasham
Chon mat<u>bakh</u>-e hagh, ze loot mala<u>amaa</u>last
Taachand be'aab-e garm, ghaane baasham

*of | the creation | I will come out | the creator | I will become*
*God forbid | that | tongue | never | stop | I will do (I won't stop my tongue)*
*since the | kitchen of | the truth | of | naked/dead bodies | is teeming*
*how long | with water of | warm | satisfied | I should be*

I will come out of this creation as the Creator
And I won't hold my tongue any longer.
Since the cremating kitchen of the truth is bursting with naked bodies
How much longer should I be satisfied with just plain warm water?

<u>1153 AK</u>

Emshab hameshab, ne<u>shas</u>te andar harabam
Fardaa beravam, menaa<u>re</u>raa kaard zanam
Khashm-aaloodast, agarche baamaast sanam
Dar chaah resee<u>de</u>am, valee birasanam

🔹

*tonight | every night | seated | amidst | a war zone*
*tomorrow | I'll go | the minaret | strike with a knife | I'll do*
*full of anger/fury he is | although | he is with me | my idol/beloved*
*inside | a well | I have reached | but | without a rope I am*

🔹

Every night I find myself in the middle of a war zone.
Tomorrow, I'll go to stab the minaret with a knife.
My Beloved is so full of fury when He is with me
It's like being trapped in a well, without a rope to escape.

1154 AK

اندر طلب دوست همی بشتابم

عمرم بکران رسید و من در خوابم

گیرم که وصال دوست درخواهد یافت

این عمر گذشته را کجا دریابم

Andar talab-e doost, hamee-besh<u>taa</u>bam
Omram bekaraan resid-o, man dar khaabam
Giram ke vesaal-e doost, dar-khaaham yaaft
Een omr-e gozash<u>te</u>raa, kojaa dar<u>yaa</u>bam

*in the | desire of | the friend | I am rushing*
*my life | to the shores/fringes/end | it has reached | [yet] I am | in | asleep*
*let's say | that | union of | the friend | I'll | reach/have*
*this | life | that has passed by | where | can I find [again]*

I am rushing with the desire for the Beloved.
My life has reached its shores yet I am deep asleep.
Even if I become one with the Beloved, at the end,
The life that was wasted, where can I find it again?

1159 AK

ای جان وجهان جان جهان گم کردم

ای ماه زمین و آسمان گم کردم

می بر کف من منه بنه بر دهنم

کز مستی تو راه دهان گم کردم

Eyjaan-o jahaan, jaan-o jahaan, gom kardam
Eymaah, zameen-o aa<u>s</u>emaan, gom kardam
Mei bar kaf-e man manah, benah bar dahanam
Kaz masti-e to, raah-e dahaan gom kardam

*O life and | the world | life and | the world | lost | I have*
*O moon | earth and | the sky | lost | I have*
*wine | on | palm of | mine | don't place | place [it] | in | my mouth*
*because of | drunkenness of | you | way to | mouth | lost | I have*

O life and the world, I have lost both life and the world.
O bright Moon, I have lost the earth and the sky.
Don't place more wine in my hand, pour it in my mouth.
I am so drunk on you that I have lost the way to my mouth.

1167 UT

Mipen<u>daa</u>ree, ke man befarmaan-e khodam
Yaa yek nafas-o, neem nafas aan-e khodam
Maanand-e ghalam, peesh-e ghalamraan-e khodam
Chon gooy, aseer-e meer-e chogaan-e khodam

*you think | that | I [am] | in command of | myself*
*or | one | breath and | half | breath | belongs to | myself*
*similar to a | pen | next to | pen master/writer of | myself*
*like a | ball | captive of | master of | polo of | myself*

Do you think I am in command here?
Do you think that even a single breath belongs to me?
I am like a pen in the hand of a writer, who is indeed myself
Like a polo stick, surrendered to the polo master, who is me.

1179 AK

بر شاه حبش زنیم و بر قیصر روم

پیشانی شیر بر نویسیم رقوم

ما آهن لشکر سلیمان خودیم

جز در کف داود نگردیم چو موم

❖

Bar shaah-e habash zaneem-o, bar gheisar-e room
Pishaaniye sheer, bar-neviseem roghoom
Maa aahan-e lashkar-e, soleimaan-e khodeem
Joz dar kaf-e Daavood, nagardeem cho moom

❖

*to the | king of | Abyssinia | we will attack and | to the | caesar of | Rome*
*[on] the forehead of | a lion | we shall write | repeatedly/continuously*
*we | the iron/metal of | the army of | Solomon of | ourselves are*
*except | in the | palm of | David | we won't become | [molded] like a | wax*

❖

We will attack the king of Abyssinia, and the caesar of Rome,
And we will write our legend on the forehead of lions.
We are the metal that is used for an army, the size of Solomon's.
We won't become molded like a wax in anyone's palm, except David's.

1182 AK

Booye dahan-e to, az chaman mishe<u>na</u>vam
Rang-e to, ze laale-o, saman mishe<u>na</u>vam
Inham-cho nabaa<u>sha</u>dam, labaan bog<u>shaa</u>yam
Taa naam-e to migooyad-o, man mishe<u>na</u>vam

*the fragrance of | mouth of | yours | from | the grass | I hear/sense*
*the color of | you | from | tulip and | jasmine | I hear/sense*
*even if this | I wouldn't have | my lips | I open*
*until | name of | you | it says/repeats and | I | hear/sense*

I smell the fragrance of your mouth in the grass.
I see the color of your face in the lily and jasmine.
Even without these, I just open my lips
And hear your name being repeated over and over again.

1186 AK

بیکارشدم ای غـــــم عشقت کارم
دربیکاری تخـــــم وفا مکارم

من صورت وصل می ترا شم شب وروز
باخاطرچون تیشه مگر نجارم

❖

Beekaar shodam, ey gham-e eshghat kaaram
Dar beekaari, tokhm-e vafaa mikaaram
Man soorat-e vasl, mita<u>raa</u>sham shab-o rooz
Baa khaater, chon tishe, magar naj<u>jaa</u>ram

❖

*out of work | I have become | O | the sorrow of | your love | my work*
*in | unemployment | the seed of | devotion/faith | I am planting*
*I | the face of | union | am carving | night and | day*
*with | imagination | like a | chip axe | as if | I am a carpenter*

❖

I am out of work but your love's sorrow is my new duty.
In these jobless days I am planting the seeds of devotion.
Night and day I carve the immaculate face of union
With my imagination, like a chip axe, as if I were a carpenter.

1190 AK

تا ترک دل خویش نگیری ندهم

و انچت گفتم تا نپذیری ندهم

حیلت بگذار و خویشتن مرده مساز

جان و سر تو که تا نمیری ندهم

Taa tark-e del-e kheesh nageeri, nadaham
Va aanchat goftam, taa napa<u>zee</u>ri nadaham
Heelat begozaar-o, kheeshtan mordeh masaaz
Jaan-o sar-e to, ke taa nameeri nadaham

*until | abandon | the heart of | yourself | you don't do | I won't give*
*and | what | I have said | until | you don't accept | I won't give*
*tricks | let go of | yourself | like a dead person | don't make (pretend)*
*[swear to your] soul and | head of | you | that | until | you don't die | I won't give*

Until you abandon your own desires, I won't give in.
Until you accept my commands, I won't give in.
Stop your cheap tricks, stop playing dead all the time.
I swear on your life until you are dead, I won't give in.

1195 AK

تا روی تو بدیدم از جهان سیر شدم

روباه بدم ز فر تو شیر شدم

ای پای نهاده بر سر خلق ز کبر

این نیز بیندیش که سر زیر شدم

---

Taa rooye to deedam, ze jahaan seer shodam
Roobaah bodam, ze far_r-e_ to sheer shodam
Ey paay nahaadeh, bar sar-e khalgh ze kebr
In neez biyan<u>dee</u>sh, ke sar zeer shodam

---

*when | the face of | you | I saw | of | the world | satiated/gratified | I became*
*a fox | I was | of | splendor of | you | a lion | I became*
*O | feet | you have placed | on the | head of | the public | because of | pride*
*this | also | you should consider | that | head | lowered | I have become*

---

When I saw your face I renounced the world.
Through your splendor, my fox-like nature was transformed into a lion.
You are holding the arrogant heads of the people low with your feet.
Consider this as well, I have also learned to lower my head.

1208 UT

خواهم که ز عشق تو ز جان برخیزم

ور بهر تو از هر دو جهان برخیزم

خورشید تو خواهم که به باران برسد

چون ابر زپیش تو از ان برخیزم

⬚

Khaaham ke ze eshgh-e to, ze jaan barkheezam
Vaz bah'r-e to, az har do jahaan barkheezam
Khorsheed-e to, khaaham ke, bebaaraan beresad
Chon ab'r az peesh-e to, az aan barkheezam

⬚

*I want | that | of | love of | you | of | life | I rise*
*and | for | you | of | all | two | worlds | I rise*
*the sun of | you | I want | that | to the rain | it reaches*
*like | cloud | of | side/next to | you | of | that | I rise (to evaporate)*

⬚

Your love lifts my soul from the body to the sky
And you lift me up out of the two worlds.
I want your sun to reach my raindrops,
So your heat can raise my soul upward like a cloud.

1227 AK

Dar har falakee, mardomakee meebinam
Har mardomakashraa falakee meebinam
Ey ahval, agar yekee do meebini to
Baraks-e to, man doraa yekee meebinam

*in | every/all | cosmos | a pupil [of the eye] | I see*
*every | pupil | a cosmos | I see*
*O | cross-eyed person | if | a one | two | you see | you*
*unlike | you | I | a two | one | I see*

In every cosmos I see a pupil of the eye
Every one of the pupils I see as the cosmos.
You may be cross-eyed and see one as two,
But unlike you, I see the two as one.

1249 AK

زین پیش اگر دم از جنون می‌زده‌ام

وانگه قدم از چراو چون می‌زده‌ام

عمری بزدم اندر و چون بگشادند

دیدم ز درون در برون می‌زده‌ام

Zeenpeesh agar, dam az jonoon meezade'am
Vaangah ghadam az, cheraav-o choon meezade'am
Omree bezadam eendar-o, choon bog<u>shaa</u>dand
Deedam ze daroon, dar boroon meezade'am

*any time before | if | talk | of | madness | I have done*
*and then | complain | of | why and | because (this and that) | I have done*
*a life time | I pounded | this door and | when | they opened it*
*I saw | from | inside | on | the outside | I have been pounding*

All the time before, my talk was only madness.
And I complained about this and that.
For a lifetime I pounded this door, and when they opened it
I saw I had been pounding from the inside.

1254 UT

Emrooz yekee, gardesh-e mastaane konam
Vaz kaaseye sar, saaghar-o peimaane konam
Emrooz dareen shah'r, hameegardam mast
Meejooyam aa<u>gh</u>eli, ke divaane konam

*today | one | turn/spin/samaa of | drunken | I'll do*
*and of | skull of | the head | cup and | a vessel | I'll do (make)*
*today | in this | city | I am strolling | drunk*
*I am seeking | an intellectual | so that | mad | I'll do*

Today I'll do an intoxicating samaa
And out of my skull I will form a cup.
Today I am walking about drunk in this town
Seeking an intellectual, so I can turn him mad.

1256 AK

شاعرنیم و زشاعری نان نخورم

وزفضل نلافم وغم آن نخورم

فضل و هنرم یکی قدح میباشد

وان نیز مگر ز دست جانان نخورم

◈

Shaa'er neeam-o, ze shaa'eri naan nakhoram
Vaz fazl nalaa<u>fam</u>-o, ghame aan nakhoram
Fazl-o honaram, yeki ghadah mibaashad
Vaan neez magar, ze dast-e jaanaan nakhoram

◈

*a poet | I am not | and | of | poetry | bread (livelihood) | I won't eat*
*and of | grace/excellence | I am not boasting | worry/grief of | that | I won't eat/do*
*the excellence and | my art | one | cup | it all is*
*and that | also | unless | [comes] from | the hands of | the soul of souls/ Beloved | I won't eat/receive*

◈

A poet I am not, and poetry doesn't provide my livelihood.
I don't boast about excellence for it doesn't concern me.
My art and excellence are but a single cup
And unless it's from the Beloved's hand I won't even touch it.

1261 UT

<div dir="rtl">

چندان که بکار خود فرو می بینم

بی دیدگی خویش نکو می بینم

تا زحمت چشم خود چه خواهم کردن

اکنون چو جهان بچشم او می بینم

</div>

Chandaan-ke, bekaar-e khod foroo meebeenam
Bee deedegiye kheesh, nekoo meebeenam
Taa zahmat-e cheshm-e khod, che khaaham kardan?
Aknoon, cho jahaan be<u>cheshm</u>-e oo meebeenam

*so much | in the work of | my self | deep | I see*
*without | sight of | my self | good/clear | I see*
*so that | bother the | eyes of | myself | why | I want/should | do*
*now | because | the world | in the eyes of | him | I see*

I see so deeply within myself.
Not needing my eyes, I can see everything clearly.
Why would I want to bother my eyes again
Now that I see the world through His eyes?

1262 UT

<div dir="rtl">
ماهی ی فارغ ز چارده می بینم

بے چشم بسوی ماه ره می بینم

گفتی که : ازو همه جهان آب شد ست

آوخ ! که در این آب چه مه می بینم
</div>

Maahi faaregh, ze chaardah meebeenam
Bee cheshm besooye maah, rah meebeenam
Goftee ke, "Azoo hame jahaan aab-shodast"
Aakh! Ke dar een aab, che mah meebeenam

*a moon | free/not needing | of | fourteen (fourteenth day of the moon cycle/night
of the full moon) | I see
without | eyes | toward the | moon | a path | I see
you said | that | because of him | all | the world | has turned to water
ah | that | in | this | water | what | moon | I see*

The moon is not yet full, but I see a full moon in front of me.
Not needing my eyes, I see a path toward that moon.
You said, "He has turned the world to water."
Ah, what a full moon I see in that water.

1265 UT

Deldaar cho deed, khaste-o ghamgeenam
Aamad, khandaan neshast bar baaleenam
Khaareed saram, begoft ke, "Ey meskeenam
Ham meenadahad del, ke cheninat beenam"

*sweetheart | when | he saw | [how] tired and | sad I am*
*he came | laughing | sat | by | my bed side*
*he scratched | my head | and said | that | O | my poor*
*it is | not so good/pleasant | to the heart | that | like this you | I see*

The sweetheart came in and found me tired and sad.
He smiled, walked toward me and sat by my side.
Scratching my head, he said, "O my poor...,
It's not so good, seeing you like this."

1284 UT

دستارم و جبه و سرم، هر سه بهم
قیمت کردند، بیک درم چیزی کم

نشنیدستی تو نام من در عالم
من هیچ کسم، هیچ کسم، هیچ کسم

◆

Dastaaram-o jobbe-o saram, har se beham
Gheimat kardand, beyek deram cheezee kam
Nashneedasti, to naam-e man dar aalam?
Man heechkasam, heechkasam, heechkasam

◆

*my kerchief and | my cape and | my turban | all | three | together*
*appraised | they did | one | drachma | something | small*
*haven't heard | you | name of | mine | in | the world*
*I | am a nobody | am a nobody | am a nobody*

◆

My kerchief, my cape and my turban—all three
Were appraised at a very small amount.
Haven't you heard my name throughout the world?
I am a nobody, a nobody, a nobody.

1287 AK

گر صبر کنی پرده صبرت بدریم

ور خواب روی خواب زچشمت ببریم

گر کوه شوی در آتشت بگدازیم

ور بحر شوی تمام آبت بخوریم

◈

Gar sab'r konee, pardeye sabrat bedareem
Var khaab-ravee, khaab ze cheshmat bebareem
Gar kooh shavee, dar aatashat bog<u>daa</u>zeem
Var bah'r shavee, tamaam-e aabat bekho<u>ree</u>m

◈

*if | patient | you do | curtain/veil/secret of | your patient | I'll rip*
*If you | fall asleep | sleep | off | your eyes | I'll rub*
*if | mountain | you become | in | fire you | I'll melt (you)*
*and if | a sea | you become | all of | your water | I'll drink*

◈

If you show patience, I'll rid you of this virtue.
If you fall asleep, I'll rub the sleep from your eyes.
If you become a mountain, I'll melt you in fire
And if you become an ocean, I'll drink all your water.

1289 UT

Sar dar, sar-e-khaak-e aastaan-e to naham
Del dar, kham-e zolf-e delestaan-e to naham
Jaanam belab aamadast, lab peeshe man aar
Taa jaan bebahaane, dar dahaan-e to naham

*head | over | at the ground of | threshold of | you | I place*
*heart | over | at the curl of | hair of | province of the heart of | you | I place*
*my life | up to the lips | has come | lips | next to | me | bring*
*until | life | in excuse | into | mouth of | you | I place*

I touch the soil of your threshold with my head.
My heart is tangled by the lockets of your dark hair.
Life has reached up to my lips—bring your lips next to mine
So at last I could place my life into your sweet mouth.

1293 UT

<div dir="rtl">

ما کار و دکان و پیشه را سوحته ایم

شعر و غزل و دو بیتی آموحته ایم

در عشق، که او جان و دل و دیده ماست

جان و دل و دیده، هر سه را سوحته ایم

</div>

◼

Maa kaar-o dokaan-o peesheraa, sookh<u>t</u>eeem
She'er-o ghazal-o dobeitee, aamookh<u>t</u>eeem
Dar eshgh, ke oo jaan-o del-o deedeye maast
Jaan-o del-o deedeh, har seraa sookh<u>t</u>eeem

◼

*we | work and | store and | craft | have burned*
*poetry and | love songs and | couplets | have learned*
*in | love | which | he [is] | soul and | heart and | vision of | ours*
*soul and | heart and | vision | all | the three | have burned*

◼

We have set blaze to our work, store, and profession.
We have learned instead poetry, love songs, and couplets.
In love, He is our heart, soul, and vision;
Heart, soul and vision, we have set blaze to all three.

1301 AK

Gah dar talab-e vasl, moshavash baasheem
Gaah az ta'ab-e hejr, dar aatash baasheem
Chon az man-o to, een man-o to paak shavad
Angah man-o to, bee man-o to, khosh baasheem

*at times | in | the search of | union | disturbed | we are*
*at times | of | fatigue of | separation | in | fire | we are*
*when | of | me and | you | this [Illusion of] | me and | you | erase | it becomes*
*then | me and | you | without | me and | you | blissful | we are (we will be)*

At times we seem disturbed on the path of union.
At times we scorch in the fire of the pain of separation.
When this illusion of you-and-I disappears from me-and-you
Then me-and-you, without the veil of you-and-I, will live in bliss together.

1303 UT

یکچند بکودکی بہ استاد شدیم

یکچند بروی دوستان شاد شدیم

پایان حدیث ما تو بشنو کہ چہ شد

چون ابر در آمدیم، و چون باد شدیم

Yekchand bekoo<u>d</u>aki, beostaad shodeem
Yekchand berooye doostaan, shaad shodeem
Paayaan-e hadees-e maa, to beshn-o ke che shod
Chon ab'r daraamadeem, va chon baad shodeem

*for a while | at a young age | a master | I became*
*for a while | at the sight of | friends | happy | I became*
*the end of | legend of | mine | you | listen | that | what | happened*
*like | a cloud | I came in | and | like a | wind [free] | I became*

For a while, at a young age, I became a master.
For a while, I was happy at the sight of friends.
Now, listen to the end of my legend, see what happened—
I came in like a cloud, and I left like a wind.

1316 UT

ما ئیم، که دوست خویش دشمن داریم

ما دشمن هر عاشق و هر بیداریم

با قاصد دشمنان خود ما یاریم

ما دامن خود همیشه درخون داریم

---

Maayeem, ke doost-e kheesh, doshman daareem
Maa doshman-e har aashegh-o, har beedaareem
Baa ghaased-e doshma<u>nan</u>-e khod, maa yaareem
Maa daaman-e khod, hameeshe dar khoon daareem

---

*it is me | who | friend of | myself | enemy | I have*
*I | enemy of | every | lover and | every | awakened ones I am*
*with | messenger of | enemies of | myself | I | am friend*
*I | skirt of | myself | always | in | blood | I have*

---

I am an enemy to my friends.
I am an enemy to every lover and awakened one.
I am friends with the messengers of my enemy.
I always have blood on my skirt.

1322 UT

بی دف بر ما میا، که ما در سوریم

برخیز و دهل زن، که ما منصوریم

مستیم، نه مست بادهٔ انگوریم

از هرچه خیال بردهٔ، ما دوریم

◈

Bee daf bar maa mayaa, ke maa dar-sooreem
Bar<u>khee</u>z-o dohol bezan, ke maa mansooreem
Masteem, nah mast-e baadeye angooreem
Az harche kheeyaal borde'i, maa dooreem

◈

*without | a frame drum | to | us | don't come | for | we | are in festivity*
*get up and | the drum | play | for | we | are victorious*
*we are drunk | not | drunk of | wine of | grapes*
*of | any | thoughts | you have | we | are far*

◈

We are celebrating, don't come to us without a daf.
Get up and play the drum, for we are victorious.
We are drunk, but not drunk on grape's wine;
Anything you can think of, we are far, far from that.

1325 AK

مائیم که گه نهان و گه پیدائیم
گه مؤمن و گه یهود و گه ترسائیم

تا این دل ما قالب هر دل گردد
هر روز بصورتی برون میائیم

<div align="center">✦</div>

Maaeem ke, gah nahaan-o, gah peydaaeem
Gah mo'men-o, gah yahood-o, gah tarsaaeem
Taa indel-e maa, ghaaleb-e har del gardad
Har rooz besoorati, beroon meeaaeem

<div align="center">✦</div>

*it is me/us | who | at times | hidden and | at times | revealed we are
at times | faithful/devoted (Muslim) and | at times | a Hebrew and | at times | a
Christian we are
in order to/until | this heart of | mine\ours | fit [inside] | every | heart | it does
every | day | with a [different] face | out | we come*

<div align="center">✦</div>

This is me: Sometimes hidden and sometimes revealed,
Sometimes a devoted Muslim, sometimes a Hebrew and a Christian.
For me to fit inside everyone's heart,
I put on a new face everyday.

1331 AK

Man bandeye ghor'aanam, agar jaan daaram
Man khaak-e dar-e, Mohammad-e mokhtaaram
Gar nagh'l konad joz een, kas az goftaaram
Beezaaram az oo, vaz eensokhan beezaaram

*I | servant/slave of | the Koran am | if/until | life | I have*
*I | the dust of | door of | Mohammad who | is free/liberated am*
*if | convey/repeat | does | except | this | anyone | of | my words*
*disgusted I am | of | him | and of | this word | am disgusted*

As long as I have life I am enslaved to the teachings of the Koran
I am the dust at the door of Mohammad the Free.
If anyone conveys this message in any other way,
I will be disgusted with him and any word he will say.

1342 UT

Man seer<u>nee</u>am, seer<u>nee</u>am, seer<u>nee</u>am
Zeeraake ze egh<u>baal</u>-e to, adbeer neeam
Khargoosh nakhaham, va nageeram aahoo
Joz aashegh-o, Joz taaleb-e aan sheer, neeam

*I | am not satiated | am not satiated | am not satiated*
*because | of | fortune of | you | distant | I am not*
*rabbit | I don't want | and | I won't accept | deer [meat]*
*except | in love and | except | in the desire of | that | lion (the Beloved) | I am not*

I am not satiated, not satiated, not satiated
Because I am not far from your good fortune.
I don't want any rabbit, nor would I accept any deer meat.
I don't want anything except to be in love with that lion, the Beloved.

در عالم گِلِ گنج نهانی مائیم

دارنده مُلکِ جاودانی مائیم

چون از ظلمات آب و گِلِ بگذشتیم

هم خضر و هم آب زندگانی مائیم

Dar aalam-e gel, ganj-e nahaani maayeem
Daaran<u>de</u>ye molk-e jaav'daani, maayeem
Chon az zala<u>maa</u>t-e aab-o gel, bog<u>zash</u>teem
Ham khezr-o ham aab-e-zendegaani, maayeem

*in | the world of | mud | treasure of | hidden | I am*
*the possessor of | land of | eternity/eternal | I am*
*because | of | hardships of | water and | mud (destiny/life) | I have passed*
*not only | Khezr | but also | water of life | I am*

In this world of mud I am the hidden treasure.
I am the owner of the land of the eternal life.
Since I have passed the hardships of this world
I have become Khezr and the water of life.

1372 UT

Ey doost, ghaboolam kon-o, jaanam besetaan
Mastam kon-o, vaz hard-o jahaanam, besetaan
Baa harche delam gharaar geerad, bee to
Aatash beman andar zan-o, aanam besetaan

---

*O | friend | accept me | do and | my life | liberate/conclude*
*drunken me | do and | of | both two | worlds me | liberate/conclude*
*with | anything | my heart | sets | in | without |you*
*fire | to my | inside | strike and | that too | liberate/conclude*

---

O Beloved, accept me and liberate my soul.
Intoxicate me and liberate me from the two worlds.
If I set my heart on anything but you,
Let fire burn my inside and liberate me on that too.

1431 UT

هنگام اجل چو جان به پردازد تن

مانند قبای کهنه، اندازد تن؛

تن را که ز خاکست دهد باز به خاک

وز نور قدیم خویش بر سازد تن

◈

Hangaam-e ajal, cho jaan bepardaazad tan
Maanand-e ghabaaye kohne, andaazad tan
Tanraa ke khaakast, dahad baaz be khaak
Vaz noor-e ghadeem-e kheesh, bar saazad tan

◈

*at the time of | death | when | the soul | spends | the body*
*similar to | garb of | old/worn out | drops | the body*
*the body | which | is dust | gives | again | to | dust*
*and of | light of | old of | himself | again | creates | the body*

◈

At the moment of death when the soul has used up the body,
It drops the limp corpse like a worn out rag.
This body of dust is returned back to dust
And the soul, through its pure ageless light, creates another body.

1449 UT

<div dir="rtl">

ای جان منزه ز غم پالودن

وی جسم مقدس ز غم فرسودن

این آتش عشقی که در او می سوزی

این جنت فردوس تو خواهد بودن

</div>

Ey jaan-e monaz'zeh, ze gham paaloodan
Vey jesm-e moghad'das, ze gham farsoodan
Een aatash-e eshghee ke, daroo misoozee
Een jannat-e ferdos-e to, khaahad boodan

*O | soul of | pure | of | sorrow | to refine*
*and O | body of | holy | of | sorrow | to obliterate*
*this | fire of | love | which | in it | you are burning*
*this | garden of | paradise of | you | will | be*

O pure soul, it is sorrow that refines you.
O holy body, it is sorrow that obliterates you.
This fire of love that you are burning in
Will be your garden of paradise.

1454 UT

اى عادت تو خشم و جفاورزيدن

ور چشم تو، شايد اين سخن پرسيدن

زين گونه كه ابروى تو با چشم خوشست

او را ز چه رو نمى تواند ديدن؟

◈

Ey aadat-e to, khashm-o jafaa var<u>zee</u>dan
Vaz cheshm-e to, shaayad een sokhan por<u>see</u>dan
Zeen gone ke, abrooye to baa cheshm khoshast
Ooraa, az che roo, nemi<u>tavaa</u>nad deedan?

◈

*O | habit of | you | anger and | unkindness | is to practice*
*and of | eyes of | you | perhaps | this | word | [one should] ask*
*this | way | that | eyebrows of | you | with | eyes | are having fun*
*they | of | what | reason | can not | see [each other]*

◈

You constantly show us your wrath and anger.
Perhaps you should ask your eyes this question:
If your eyes and eyebrows are having such a great time
Why is it that they can't see each other?

1475 UT

تا با خودی دوری ، ارچه هستی با من

ای بس دوری ، که از تو با شد تا من

در من نرسی تا ، نشوی یکتا من

اندر ره عشق یا تو باشی ، یا من

<center>◈</center>

Taa baa khodee doori, arche hastee baa man
Ey bas dooree, ke az to baashad taa man
Dar man naresee, taa nashavee yektaa man
Andar rah-e eshgh, yaa to baashee, yaa man

<center>◈</center>

*until | with | yourself you are | you are far | even if | you are | with | me*
*O | so much | you are far | that | of | you | [a distance] it is | to | me*
*to | me | you won't reach | until | you don't become | unified/one | [with] me*
*in | the | path of | love | either | you | remain | or | me*

<center>◈</center>

Hold on to yourself, lose my intimacy, even if you are with me.
You are a great distance away from me.
You won't reach me until you merge with me
In the path of love, either "you" remain or "I."

1482 UT

<div dir="rtl">

از بس که برآورد غمت آه از من

ترسم که شود بکام ، بدخواه از من

دردا که زهجران توای جان وجهان

خون شد دلم و دلت آنگاه از من

</div>

❖

Az bas-ke baraavard ghamat, aah az man
Tarsam ke shavad bekaam, badkhaah az man
Dardaa-ke ze hejraan-e to, ey jaan-e jahaan
Khoon shod delam-o, delat na-aagaah az man

❖

*because | so often | brought out | your sorrow | sigh | from | me*
*I fear | that | becomes | gratified/pleased | my foe | from | me*
*it is painful | of | the separation of | you | O | soul/life of | the world*
*bloody | became | my heart and | your heart | not aware | of | me*

❖

I am always in tears when you are not with me
I cry so much, I fear this will please my enemy.
Being away from you, O soul of the world, is being in constant pain.
My heart is all bloody yet you are not aware of me.

1495 UT

بی دل من و بی دل تو و بی دل تو و من

سرمست همی شدیم، روزی به چمن

عمرست که من در آرزوی آنم

کان عهد بیاد آری، ای عهد شکن

Beedel-e man-o, beedel-e tov-o, beedel-e tovoman
Sarmast hamee-shodeem, roozee bechaman
Omreest ke man, dar aare<u>zoo</u>ye aanam
Kaan a<u>hd</u> beyaad aari, ey a<u>hd</u> shekan

*without the heart of | mine and | without the heart of | you and | without the
heart of | you and I*
*drunk | we headed | one day | toward the grass/green field*
*it is a life time | that | I | in the | wish of | that [thing] I am*
*for that | promise | remember | you | O | promise | breaker*

Without my heart, without your heart, without the hearts of "you"
and "I"
Drunk we headed one day toward the green fields.
I have been wishing for a lifetime
That you would remember your promise, O breaker of promises.

1502 UT

ای مونس روزگار، چونے بی من

ای همدم و غمگسار، چونے بی من

من بارخ چون خزان، خرابم بے تو

تو بارخ چون بهار، چونے بی من

Ey mones-e roozegaar, chonee bee man?
Ey hamdam-o ghamgosaar, chonee bee man?
Man baa rokh-e chon khazaan, kharaabam bee to
To baa rokh-e chon bahaar, chonee bee man?

*O | companion of | the days/destiny | how are you | without | me*
*O | confident one and | the sympathetic one | how are you | without | me*
*I | with | face of | like | autumn | am desolate | without | you*
*you | with | face of | like | spring | how are you | without | me*

O companion of fate, how are you without me?
O the compassionate friend, how are you without me?
I am desolate without you, my face sallow as the Autumn leaves
You, with a face like Spring, how are you without me?

1504 AK

---

Goftam ke, bar hareef-e ghamgeen manesheen
Joz pahlooye, khoshdelaan-e sheereen manesheen
Dar baagh cho aamadee, sooye khaar maroo
Joz baa gol-o, yaasmeen-o nasreen manesheen

---

*I said | that | next to | the partner of | sad | don't sit*
*except | next to the | cheerful ones and | sweet [ones] | don't sit*
*in | the garden | since | you have come | toward the | thorn | don't go*
*except | with | flower/rose and | jasmine and | jonquil | don't sit*

---

I told you, don't sit next to a sad person.
Don't sit anywhere except by the cheerful ones.
Now that you are in the garden, don't go toward the thorns—
Don't sit anywhere except with the rose, jasmine, and jonquil.

دل برد ز من دوش، بصد عشق و فسون

بشکافت و بدید، پر زخون بود درون

فرمود، در آتشش نهادن حالی

یعنی که نپخته ست، از آنست پر خون

Del bord ze man doosh, besad eshgh-o fosoon
Beshkaaft-o bedeed, Por ze khoon bood daroon
Farmood, dar aatashash nahaadan haalee
Ya'nee ke napokhteast, az aanast por khoon

*heart | stole | of | me | last night | with a hundred | love | charms/spells*
*he opened and | he saw | full | of | blood | was | inside [the body]*
*he said | in | him in the fire | place | for a while*
*which means | that | he is uncooked/raw | of | that's why he is | full of | blood*

He stole my heart last night with a hundred love spells
He opened my chest and found it was full of blood.
He said, "Place him in the fire for a while."
Which means, he is still unbaked, that is why he is so full of blood.

1515 UT

رو ، درد گزین ، درد گزین ، درد گزین

زیرا که ره چاره ندارم جز این

دلتنگ مشو ، که نیست بخت قرین

چون درد نباشدت ، بدان باش حزین

◈

Ro, dard gozeen, dard gozeen, dard gozeen
Zeera ke rah-e-chaareh, nadaaram joz een
Deltang masho, ke neestat bakht ghareen
Chon dard nabaa<u>sha</u>dat, bedaan baash hazeen

◈

*go | pain | you choose | pain | you choose | pain | you choose*
*because | that | the way out/answer to a problem | I don't have | except | this*
*lonely/sad | don't feel | because | you don't have | destiny/faith | as your friend*
*if | pain | you don't have | of that | you should be | sorrowful*

◈

Go and choose pain, choose pain, choose pain.
I have no answer to the problem, except pain.
Don't feel lonely, don't say you have no companions.
It is the lack of pain that calls for real concern.

من دفترهای مصر و بغداد ای جان

کردم پر زآه و فریاد ای جان

یکساعت عشق صد جهان بیش ارزد

صد جان بفدای عاشقی باد ای جان

Man daftar<u>haa</u>ye, mesr-o ba<u>gh</u>daad, eyjaan
Kardam por, ze aahoo faryaad, eyjaan
Yeksaa'at-e eshgh, sad jahaan beesh arzad
Sad jaan befa<u>daa</u>ye aa<u>sh</u>eghi baad, eyjaan

*I | the books of | Egypt and | Bagdad | O soul*
*I did | full | of | sigh and | scream | O soul*
*an hour of | love | a hundred | worlds | more | it is worth*
*a hundred | lives | in sacrifice of | being in love | let it be | O soul*

The books of Egypt and Bagdad, O soul;
I have filled with my cries and screams, O soul.
An hour of love is worth more than a hundred worlds—
Let a hundred lives be offered to love, O soul.

1516 AK

من عاشق عشق و عشق هم عاشق من

تن عاشق جان آمد و جان عاشق تن

که من آرم دو دست در گردن او

گه او کشدم چو دلربایان گردن

<div align="center">❖</div>

Man aa<u>shegh</u>-e eshgh-o, eshgh ham aa<u>shegh</u>-e man
Tan aa<u>shegh</u>-e jaan aamad-o, jaan aa<u>shegh</u>-e tan
Gah, man aaram do dast, dar gardan-e oo
Gah, oo ke<u>sha</u>dam cho delro<u>baa</u>yaan, gardan

<div align="center">❖</div>

*I | in love with | love and | love | also | in love with | me*
*body | in love with | the soul | it became and | soul | in love with | body*
*sometimes | I | bring | both | arms/hands | around | neck of | his*
*sometimes | he | pulls my | like | heartstealers/lovers | neck*

<div align="center">❖</div>

I am in love with love and love is in love with me.
The body has fallen in love with the soul, and the soul with the body.
Sometimes I put my arms around His neck
Sometimes, like lovers, He pulls my neck close to Him.

1526 UT

گفتم روزی که : من بجانم با تو
دیگر نشدم تبا ، همانم با تو

لیکن دانم که هر چه بازم ، ببری
زان میبازم ، که تا بمانم با تو

Goftam roozee ke, man bejaanam baa to
Deegar nashodam botaa, hamaanam baa to
Leekan daanam ke, harche baazam, bebaree
Zaan meebaazam, ketaa bemaanam baa to

*I said | one day | that | I | have a soul connection | with | you*
*again | I will not become | without you | that I am | with | you*
*yet | I know | that | everything | I lose | you win*
*because of that | I lose | so that | I stay | with | you*

One day I said our souls are one—
I will never be without you again.
I know you win everything I lose—
I lose, so that I can stay with you.

1540 UT

در اصل یکے بُدست جان من و تو
پیدایے من و تو ، و نهان من و تو

خامے باشد که گویی : آن من و تو
برخاست من و تو ، از میان من و تو

Dar-asl yekee bodast, jaan-e man-o to
Pei<u>daa</u>y-e man-o to, va nahaan-e man-o to
Khaamee baashad, ke gooyee "Aan-e man-o to"
Barkhaast man-o to, az miyaan-e man-o to

*originally | one | has been | the soul of | me and | you*
*[what's] revealed of | me and | you | and | hidden of | me and | you*
*unbaked/immature | it would be | that | you say | the thing of | me and | you*
*left/rose up | me and | you | of | the middle of | me and | you*

From the beginning, the soul of you and I has been one.
What is exposed of you and I, and what is hidden,
It is naive to say, "That belongs to you and I."
This illusion of you and I is no longer between me and you.

1543 UT

من بندۀ تو ، بندۀ تو ، بنـــــدۀ تو

من بندۀ آن رحمت خنـــدندۀ تو

ای آب حیات ، کی ز مرگ اندیشید

آنکس که چو خضـــر گشت او زندۀ تو

Man bandeye to, bandeye to, bandeye to
Man bandeye aan rahmat-e, khandan<u>deye</u> to
Ey aab-e hayaat, kee ze marg andeeshad
Ankas ke cho Khezr, gasht oo zendeye to?

I | am slave of | you | slave of | you | slave of | you
I | am slave of | that | mercy of | laughing of | you
O | water of | life | who | of | death | can think
the one | who | like | Khezr | became | he | alive by | you

I am your slave, I am your slave, I am your slave.
I am the slave of that laughing mercy of yours.
O water of life, who can think of death
When, like Khezr, one has become alive by you?

1552 UT

Chon paak shod az khodeeye to, seeneye to
Khod beengardee, ze yaar-e deerineye to
Bee aayene, rooye kheesh, natavaanee deed
Dar yaar negar, ke oost aayeeneye to

when | pure | it became | of | selfhood of | you | chest of | you
yourself | will see | of | the beloved of | old of | you
without | a mirror | face of | yourself | you can't | see
at | the beloved | look | who | he is | the mirror for | you

When your chest is free of your limiting ego,
Then you will see the ageless Beloved.
You can not see yourself without a mirror;
Look at the Beloved, He is the brightest mirror.

1557 UT

در کوی خیال، خود چه می پویی تو

وین دیده بخون دل چه می شویی تو

از فرق سرت تا بقدم، حق دارد

ای بی خبر از خویش چه می جویی تو

⬛

Dar kooye khiyaal-e khod, che mipooyee to?
Vin deedeh bekhoon-e del, che mishooyee to?
Az fargh-e sarat taa beghadam, hagh daarad
Ey beekhabar az kheesh, che mijooyee to?

⬛

*in | the alley of | imagination of | yourself | what | are searching | you*
*and this | sight/eyes | with the blood of | heart | what | are washing | you*
*from | the crown of | your head | to | the step/feet | the truth | it belongs to (all*
*that belongs to the truth)*
*O | ignorant | of | yourself | what | are looking for | you*

⬛

In the alley of your imagination, what are you searching for?
Why are you washing your face with blood-stained tears?
From the crown of your head to your toes, all is possessed by the truth;
O you, ignorant of your true self, what are you looking for?

1558 UT

رشک آیدم از شانه و سنگ، ای دلجو

تا با تو چرا رود، بگرمابه فرو

آن در سر زلف تو چرا آویزد

وین در کف پای تو چرا مالد رو

---

Rashk aayadam, az shane-o sang, ey deljoo
Taa baa to cheraa ravad, be garmaabe foroo
Aan-dar sar-e zolf-e to, cheraa aavizad?
Veen dar kaf-e paaye to, cheraa maalad roo?

---

*jealous | I become | of | comb and | stone/foot scrubbing stone | O | affable
because | with | you | why | it goes | to | the bath house | inside
in the | tip of | strand of hair of | you | why | it is hanging
and this | in the | bottom of | feet of | you | why | rubbing | face*

---

I am jealous of the comb and the foot-scrubbing stone,
Because they go to the bathhouse with you, O Beloved.
This one hangs on the strand of your hair
And the other rubs the bottom of your feet.

<div dir="rtl">

ای عشرت نزدیک، ز ما دور مشو

ور مجلس ما، ملول و مهجور مشو

انگور عدم بدی، شرابت کردند

واپس مروای شراب انگور مشو

</div>

Ey eshrat-e naz<u>dee</u>k, ze maa door masho
Vaz majles-e maa, ma<u>lool</u>-o mah<u>joor</u> masho
Angoor-e adam bodee, sharaa<u>bat</u> kardand
Vaapas maro ey sharaab, angoor masho

*O | pleasure of | near/intimate | of | me/us | apart/far | don't become*
*and of | gathering of | me/us | wearied and | separated | don't become*
*the grape of | non existence | you were | you a wine | they made*
*backward | don't go | O | wine | grape | don't become*

Don't distance yourself from us, O, the most intimate pleasure.
Please don't become weary and depart from our gathering.
You were an ageless grape, they made you into wine
Don't go backward, O wine, and become a grape again.

1601 UT

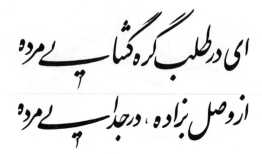

Ey dar talab-e, gereh go<u>shaa</u>yee mordeh
Az vasl bezaadeh, dar jodaayee mordeh
Ey bar lab-e bahr, teshne dar khaab shodeh
Vey bar sar-e ganj, az gedaayee mordeh

*O | in the | search of | knot | opening (awakening your dormant spiritual energy) |
you have died
of | the union | you were born | in the | separation | you have died
O | on the | edge of | the sea | thirsty | in | asleep | you have become
and O | on the | top of | a treasure | of | poverty | you have died*

O you who have died, taking to the grave the desire to undo your knot.
You were born in union yet died in separation.
You have fallen asleep, thirsty at the edge of a mountain spring.
You have died of poverty, on top of a treasure.

با ید بُ تو مرا بنفس طناز مده

با هر چه جز از تست، مرا ساز مده

من در تو همی گریزم از فتنهٔ خویش

من آن توم، مرا به من باز مده

Yaarab, to maraa benafs-e tannaaz madeh
Baa harche joz-az tost, maraa saaz madeh
Man dar to, hamee goreezam az fetneye kheesh
Man aan-e-to'am, maraa beman baaz madeh

*O lord | you | me | to passions of | teasing/tempting | don't give*
*with | anything | not part of | you it is | me | play around | don't give (do not toy*
*with me)*
*I | in | you | all | escape I do | of | seduction of | myself*
*I | am yours | me | to me | once more | don't give*

O Lord, don't tempt me with the senses.
Don't play me with anything that is not you.
I go toward you, escaping from the seduction of myself,
I am all yours—don't give me back to myself again.

1634 UT

دانی شب چیست؟ بشنوای فرزانه

خلوت کن عاشقان زهر بیگانه

خاصه امشب، که هست مه هم خانه

من مستم و مه عاشق و شب دیوانه

<div align="center">◈</div>

Daanee shab cheest? Beshno ey farzaane
Khalvat kon aa<u>sh</u>eghaan, ze har beegaane
Khaas-e emshab, ke hast mah ham-khaane
Man mastam-o, mah aashegh-o, shab deevaane

<div align="center">◈</div>

*do you know | night | what is | listen | O | wise person*
*solitude (separate) | do | lovers | of | every | stranger*
*especial is | tonight | for | it is | the moon | a house mate*
*I | am drunk and | moon | is in love and | night | mad*

<div align="center">◈</div>

Do you know what night is? Listen, O wise one:
First, keep the lovers away from outsiders.
Tonight is very special, for the moon is our housemate!
I am drunk, the moon is in love, and the night is totally mad.

1636 UT

گفتم که : توی سپی و منم پیمانه
من مرده ام و تو جانی نی و جانانه

اکنون بگشا در وفا ، گفت خموش
دیوانه کسی رها کند در خانه

◈

Goftam ke, "Toee mey-o, manam peymaane
Man mord<u>ea</u>m-o, to jaanee-o, jaanaane
Aknoon begoshaa, dar-e vafaa" Goft, "Khamoosh
Divaane kasee rahaa konad, dar khaane?"

◈

*I said | that | you are | wine and | I am | the cup*
*I | am dead and | you | are life and | the supreme life*
*now | open | the door of | devotion | he said | quiet*
*mad | any person | let lose | does | in | the house*

◈

I said, "You are the wine, and I am the cup,
I am dead and you are the source of life
Now open the door of devotion." He said, "Quiet
Would anyone let a madman loose in the house?"

1652 AK

Ham aayene'eem-o, ham la<u>gh</u>aaeem hame
Sar mast-e piyaa<u>le</u>ye, ba<u>gh</u>aaeem hame
Ham daafe-e ranj-o, ham sha<u>faa</u>eem hame
Ham aab-e-hayaat-o, ham sa<u>gh</u>aaeem hame

*also | I am the mirror and | also | I am the face | in all*
*head | drunk of | the saucer of | infinity I am | in all*
*also | repeller of | torture and | also | the healing I am | in all*
*also | water of life and | also | it's carrier I am | in all*

I am the mirror and I am the face
I am drunk by the saucer of infinity
I am the repeller of torture and I am the healing
I am the water of life and its carrying vessel.

خوش خوش صنما، تازه رُخان آمده

خندان، بدولب لعل گزان آمده

آن روز دلم ز سینه بُردی بس نیست

کامروز دگر به قصد جان آمده

Khosh khosh sanamaa, taazeh rokhaan aamade'i
Khandaan, bedo lab la'el-e gozaan aamade'i
Aan rooz delam ze seene bordee, bas neest
kaamrooz, degar beghasd-e jaan aamade'i?

*pleasant[-ly] | pleasant[-ly] | my idol | [with] a fresh | face | you have come*
*laughingly | with both | lips of | ruby of | select/choice | you have come*
*that | day | my heart | from | chest | you took | enough | is it not*
*that today | once more | with the intention of | life | you have come*

Joyfully, joyfully, O my idol, you have come with yet a new face!
Laughingly, you have come with lips of rarest rubies!
That day when you took my heart from my chest, it wasn't enough—
For today you have come again, asking for my life.

1667 UT

Khod-raa cho damee ze$y$aar, mahram yaabee
Dar omr-e naseeb-e kheesh, aan dam yaabee
Zanhaar, ke zaaye' nakonee aan dam-raa
Zeeraa ke cheneen damee, degar kam yaabee

*yourself | when | a breath/moment | with the lover | in close relation | you find
in the | life of | portion of | yourself | that | breath/moment | you find
alas | that | damage/spoiled | you don't do | that | breath/moment
because | that | of this nature | breath/moment | again | a few | you find*

When you find yourself with the Beloved, embracing for one breath,
In that moment you will find your true destiny.
Alas, don't spoil this precious moment
Moments like this are very, very rare.

1680 UT

---

Ey maah, baraamadi-o taabaan gashtee
Gard-e falak-e kheesh, kharaamaan gashtee
Chon daanesti, baraabar-e jaan gashtee
Chon jaan zedo cheshm-e khalgh, penhaan gashtee

---

*O | moon | you have risen and | bright/shining | you have become*
*around | heavens of | yourself | gracefully | you have turned*
*when | you understood | same level of/one with | life/soul | you have become*
*similar to | life/soul | of the both | eyes of | people | hidden | you have become*

---

O moon, you have risen and become bright.
You have danced, twirling around the heavens.
When you learn that you are one with the Truth
Like Truth itself, you too will vanish from peoples' sight.

1683 UT

Doshee<u>ne</u> maraa gozaa<u>sh</u>ti, khosh khoftee
Va emshab bedaghal, behar sooyee mee<u>of</u>tee
Goftam ke maraa taa be<u>ghi</u>yaamat joftee
Koo aan sokhanee ke, vaght-e mastee goftee

*last night | to me | you left | pleasant[-ly] | you slept
and | tonight | fraudulently | every | direction | you fall/lay
I said | that | to me | until | the day of resurrection | you are a couple
where are | those | words | that | moment/time of | drunkenness | you said*

Last night you slept and left me alone.
And tonight, pretending to be asleep, you toss in all directions.
I thought you and I are one until the day of resurrection—
What happened to your drunken promises?

1692 UT

يک بوسه ز تو خواستم، و شش دادی
شاگرد کی بودی؟ که چنین استادی

خوبی و کرم را چه نکو بنیادی
ای دنیا را، ز تو هزار آزادی

◈

Yek boose ze to khaastam-o, shesh daadi
Shaagerd-e ke boodee? Ke cheneen ostaadi
Khoobi-o karamraa, che nekoo bonyaadi
Ey-donyaaraa, ze to hezaar aazaadi

◈

*one | kiss | of | you | I asked and | six | you gave*
*student of | whom | you have been | that | such a | master you are*
*goodness and | generosity | how | great | you have erected/created*
*this world | [because] of | you | a thousand | you have freed*

◈

I asked you for one kiss, you gave me six.
You are such a master! Whose student have you been?
How great is the goodness and generosity you have created!
Now, because of you, a thousand souls in this world are free.

1695 UT

ماننده ُگل ز اصل خنـدان زادی

وز طالع و بخت خویش شادیِ شادی

سرسبز چو شاخ ِگل، و آزاده چو سرو

سروی عجبی، که از زمین ازادی

---

Maanande_ye gol ze asl, khandaan zaadi
Vaz taale-o bakht-e kheesh, shaadee, shaadi
Sarsabz cho shaakh-e gol, va aazaadeh cho sarv
Sarvee ajabee, ke az zameen aazaadi

---

*similar to | a flower | of | the essence | happy/laughing | you have been born*
*and of | horoscope/fortune and | destiny of | yourself | you are happy | are happy*
*head green/self assured | like | a stem of | flower | and | free | like | the cypress*
*a cypress of | strange you are | for | of | the earth | you are free*

---

You are born like a joyful flower,
And according to the charts of your destiny, you will be happier than happy.
Your head is high like the stem of flower, and free like the cypress.
Such a unique cypress, for you are free of this earth.

1700 UT

ازشادی تو پرست شهر و وادی
ای روی زمین آسمان اشادی

کس را گله نیست ز تو جز غم را
کز غم همه را بداده آزادی

◈

Az shaadiye to, porast shahr-o vaadee
Ey rooye zameen, va aa<u>se</u>maanraa shaadee
Kasraa geleyee neest ze to, joz ghamraa
Kaz gham hameraa bedaade'i, aazaadee

◈

of | happiness of | you | it is full | town and | valley
O | face of | the earth | and | the sky | you are making happy
any one (no one) | a complain | it is not | of | you | except | the sorrow
because of | sorrow | all people | you have given | freedom

◈

Towns and valleys are filled with your happiness.
The face of the earth and the sky are happy because of you.
There is no complaint, except of your sorrow
And it is your sorrow that bestows freedom to all.

1709 UT

Man zarreh bodam, ze kooh beesham kardi
Pas maandeh bodam, az hame peesham kardi
Darmaan-e del-e kharaab-o, reesham kardi
Sarmastak-o dastak-zan-e, kheesham kardi

I | a particle | I was | of | mountain | more me | you made
behind | stayed | I was | of | every one | ahead me | you made
cure of | heart of | ruined/lost in ecstasy and | wounded me | you made
a head drunk and | hand-clapping of | my self | you made

I was a particle, you made me greater than a mountain
I was always behind, you made me the leader of all.
You made me the cure for wounded hearts, lost in rapture
You made me dance to my own clapping, in ecstasy.

1715 UT

چون کار مسافران دینم کردی
حمال امانت یقینم کردی؛

گفتم که: ضعیفم و گرانست این بار
زورم دادی و آهنینم کردی

Chon kaar-e, mosaa<u>fe</u>raan-e deenam kardee
Hammaal-e amaanat-e, yagheenam kardee
Goftam ke "Za<u>ee</u>fam-o geraa<u>na</u>st een baar"
Zooram daadee-o, aa<u>ha</u>neenam kardee

---

*because | the work of/task of | the travelers of | religion me | you made*
*the hauler of | the keeper in trust of | conviction/faith me | you made*
*I said | that | I am weak and | it is heavy | this | load*
*strength to me | you gave and | like iron me | you made*

---

You made me the goal of travelers on the path of religion
And the trusted beholder of faith.
I said, "I am weak, and this load is too heavy."
You gave me strength and made me like a mountain of iron.

1722 UT

كيوان گردسے ، چوگردكيوان گردى
مردى گردسے ، چوگردمردان گردى

لعلى گردسے ، چوگرداين كان گردى
كانى گردسے ، چوگردجانان گردى

Keivaan gardee, cho gerd-e keivaan gardi
Mardi gardee, cho gerd-e mardaan gardi
La'lee gardee, cho gerd-e een kaan gardi
Kaanee gardee, cho gerd-e jaanaan gardi

*a Saturn/galaxy/heavens | you become | when | you around the | Saturn | you turn*
*a man | you become | when | you around the | men [of God] | you turn*
*a ruby | you become | when | you around | this | mine | you turn*
*a mine | you become | when | you around | soul of souls (God) | you turn*

You become the heavens when you turn around the heavens.
You become a man when you turn around the men of God.
You become a ruby when you turn around this mine.
You become a mine when you turn around the supreme soul.

1723 UT

خواهی که درین زمانه فـــشـــردی گردی

یا در ره دین صاحب دردی گردی

این را بجز از صحبت مردان مطلب

مردی گردی چو گرد مردی گردی

Khaahee ke dar een zamaane, fardee gardi
Yaa dar rah-e deen, saaheb-e dardee gardi
Eenraa bejoz az, sohbat-e mardaan matalab
Mardee gardi, cho gerd-e mardee gardi

*if you want | that | in | this | times/age | a distinguished person | you become*
*or | in the | path of | religion | the owner/beholder of | pain/love of God | you become*
*this | except | of | the words of | men [of God] | don't accept*
*a man | you become | when | turn around (serve) | a man [of God] | you turn*

If you want to gain self-respect in this world
Or on the path of faith, behold the pain of love.
Only accept these words from the men of God
You become a man, when you turn around a man of God.

1729 UT

صد روز دراز اگر بهم پیوندی
جان را نشود ازین فغان خرسندی

ای آنک بدین حدیث ما می خندی
مجنون نشدی هنوز دانشمندی

◈

Sad rooz-e deraaz, agar beham pei<u>van</u>dee
Jaanraa nashavad, az een faghaan khor<u>san</u>dee
Ey aank-e bedeen hadees-e maa, mee<u>khan</u>dee
Majnoon nashodee, hanooz daanesh<u>man</u>dee

◈

*a hundred | days of | long | if | with each other | you unite*
*the soul/life | won't become | of | this | wailing | contentment*
*O | person | at this | discourse/tradition of | ours | you laugh*
*mad | you haven't become | still | you are a scientist/intellectual*

◈

Even if your days of union with the Beloved are in the hundreds,
The soul will not become content with the wailing of the heart.
O you who are laughing at this discourse,
Haven't you reached madness yet? Are you still holding on to your
intellect?

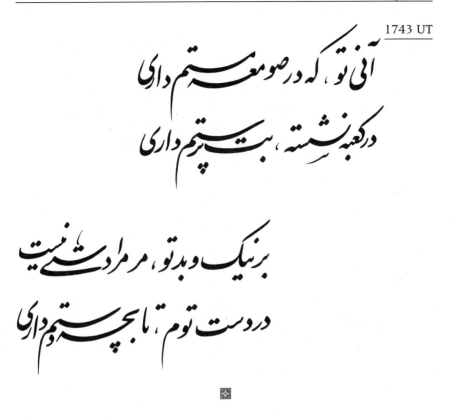

1743 UT

Aani to, ke dar some'e mastam daaree
Dar ka'be neshaste, bot parastam daaree
Bar neek-o bad-e to, mar-maraa dastee neest
Dar dast-e toam, taa beche dastam daaree

*that are | you | which | in the | monastery | me drunk | you have [made]*
*in the | Ka'be | [I] am seated | idol | worshiper me | you have [made]*
*about | good and | bad of | you | to me | any hands (control) | there is not*
*in | hands of | you I am | until | which way | my handling (controlling me) |*
*you have*

This is you, making me drunk in a monastery,
Turning me into an idol-worshipper while I am seated in Ka'be.
I have no control in this game of good and bad
I am in your hands, awaiting your gentle control.

1758 UT

آنی که بصد شفاعت و صد زاری

برپات یکی بوسه دهم نگذاری

گر آب دهی مرا، گر آتش، باری

سلطان ولایتی، و فرمانداری

Aanee ke besad shefaa'at-o, sad zaaree
Bar paat yeki boose daham, nagozaaree
Gar aab dahee maraa, gar aatash, baaree
Soltaan-e velaayatee-o, farmaandaaree

°you are that | who | a hundred | Intercessions and | a hundred | lamentations
you are
at | your feet | one | kiss | I place | you won't permit
if | water | you give | to me | if | fire | in any case
the sultan of | the province you are and | the governor

This is you: A hundred intercessions and a hundred lamentations.
I want to kiss your feet, but you will not let me.
Give me water, give me fire—regardless of what you give me,
You are the Sultan and the ruler of all lands.

1773 UT

تا پردهٔ اندیشه گری را ندری

تو پرده درسی ، پرده دری پرده دری

گویی تو که : من ز هر هنر با خبرم

این بی خبری بس ، که ز خود بی خبری

*

Taa pardeye andeeshe-gariraa, nadari
To pardeh dari, pardeh dari, pardeh dari
Gooyee to ke, "Man ze har honar baa-khabaram"
Een bee khabaree bas, ke ze khod bee khabari

*

*until | the curtain of | thinking/reflecting | you don't tear*
*you | curtain/veil | tearer you are | curtain | tearer you are | curtain | tearer you are*
*saying are | you | that | I | of | every | art | I have knowledge of*
*this | without | knowledge | enough | which | of | yourself | without | knowledge*
*you are*

*

Until you tear away the curtain of thoughts,
You are a splitter of veils, a splitter of veils.
You say, "I have knowledge of every art."
You are without any knowledge of your own self—this is true ignorance.

1776 UT

---

Baa yaar begolzaar shodam, rah-gozari
Bar gol nazaree fekandam, az bikha<u>ba</u>ri
Deldaar beman goft ke, "Sharmat baadaa
Rokhsaar-e man eenjaa vo, to dar gol negaree?"

---

*with | the Lover | to the flower field | I went | passing by*
*at | flower/rose | a glance | I placed | out of | ignorance*
*the Beloved/Lover | to me | he said | that | shame on you | be*
*the face of | me | is here | and | you | at | the flower | you look*

---

On our way, the Beloved and I entered a flower field
Not aware of the consequences, I glanced at a rose.
The Beloved said to me, "Shame on you!
My face is here and you are looking at a flower?"

1784 UT

ای حیف، که پیش کر زنی طنبوری

یا یوسف، همخانه شود با کوری

یا قند نهی، در دهن رنجوری

یا جفت شود مخنثی با حوری

❖

Ey heif, ke peesh-e kar zanee tanboori
Yaa Yoosof, hamkhaa<u>ne</u> shavad baa koori
Yaa ghand nahee, dar dahan-e ranjoori
Yaa joft shavad, mokhan<u>ne</u>si baa hoori

❖

*O | [what a] pity/injustice | that | to the | deaf | you play | a Tanboor (string instrument)*
*or | Joseph | house mate | becomes | with | a blind person*
*or | a sugar cube | you place | in the | mouth of | afflicted/ill*
*or | couple | he becomes | an impotent | with | a nymph*

❖

What an injustice it would be to play the Tanboor to the deaf
Or for Joseph to become housemate with the blind
Or to place sweet in the mouth of the afflicted
Or for an impotent to couple up with a nymph.

1784 AK

باز هره و با ماه اگر انبازی
روخانه ز ماه ساز اگر میسازی

بامی که به یک لگد فرو خواهد ریخت
آن به که لگد زنی فرود اندازی

---

Baa zohre-o baa maah, agar anbaazee
Ro khaane ze maah saaz, agar misaazee
Baamike beyek lagad, foroo khaahad reekht
Aan beh ke lagad zanee, forood andaazee

---

*with | Venus and | with | the moon | if | you are playmates*
*go | house | of | the moon | build | if | you are building [one]*
*the ceiling which | with one | kick | down ward | it will | pour*
*that | is better | which | kick | you do | down ward | you let [it] fall*

---

If your playmates are Venus and the moon
Then go and build your house from the moon.
If the roof collapses with one kick
It is better that you kick it and make it collapse.

1788 UT

<div dir="rtl">

ای طالب دنیا، تو یکی مزدوری

وی عاشق خلد، ازین حقیقت دوری

وی شاد بهر دو عالم از بیخبری

شادی غمش ندیده، معذوری

</div>

◈

Ey taaleb-e donyaa, to yekee maz<u>doo</u>ri
Vey aashegh-e kholad, azeen ha<u>ghee</u>ghat doori
Vey shaad behar do aalam, az bee<u>kha</u>baree
Shaadeeye ghamash nadeede'i, ma'zoori

◈

*O | desiring | the world | you | only [you] | are a hired slave*
*and O | lover of | paradise | of this | truth | you are far*
*and O | happy | with the | two | worlds | out of | ignorance*
*the happiness | of his sorrow | you haven't seen | you are excused*

◈

O you who desire the world, you are just a hired slave.
And you in love with paradise, you are far from the Truth.
You who are happy with the two worlds out of ignorance,
You have not experienced the happiness of His sorrow, you are excused.

1804 UT

---

Az eshgh-e to, har taraf yekee shab<u>khizee</u>
Shab gashte, ze zolfeen-e to anbar beezee
Naghaash-e azal, naghsh konad har tarafi
Az-bahr-e gharaar-e, deleman tabrizee

---

*of | love of | you | in every | direction | there is one | who stays up late*
*night | has become | of | strands of hair of | you | ambergris/curls | to sift*
*the painter of | eternity | creates a form | it does | in every | direction*
*for the sake of | comfort of | my heart | a Tabriz*

---

For your love, there is someone in every corner staying up till dawn.
Night is sifting amber from your locks of hair.
The painter of eternity is painting images in every direction.
He is painting Tabriz, for the sake of my heart's comfort.

1812 UT

Chon jomle khataa konam, savaabam to basee
Ma<u>gh</u>sood az een omr-e kharaabam, to basee
Man meedaanam, kechon be<u>khaa</u>ham raftan
Gooyand, "Che karde'i?" Javaabam to basee

*because/since | all | wrong/sin | I do | my good/right action | you | are enough*
*the goal/desire | of | this | life time of | ruined/intoxication | you | are enough*
*I | know | that when | I decide to | leave (die)*
*they say | What | has he done | my answer | you | are enough*

All I do is wrong, but you are my good action and that's enough.
The desire of this lifetime of love's intoxication is you, and that's enough.
I know when I decide to leave this body
People will ask, "What has he done?" The answer is you and that's enough.

1815 UT

تا درد نیابے ، تو بدرمان نرسی

تا جان ندہے ، بوصل جانان نرسی

تا ہمچو خلیل آتش اندر نشوی

چون خضر بسر چشمئہ حیوان نرسی

Taa dard nayaabee, to be darmaan naresi
Taa jaan nadahee, bevasl-e jaanaan naresi
Taa hamcho khaleel, aatash andar nashavee
Chon khez'r, besar-e cheshmeye heyvaan naresi

*until | pain | you don't find | you | to the | cure/remedy | you won't reach*
*until | life | you don't give | to union | soul of souls | you won't reach*
*until | like/similar to | the friend | fire | inside | you don't become*
*like | Khezr | at the edge of | spring of | animal/life | you won't reach*

Until you've found pain, you won't reach the cure
Until you've given up life, you won't unite with the supreme soul
Until you've found fire inside yourself, like the Friend,
You won't reach the spring of life, like Khezr.

1825 UT

<div dir="rtl">

با صورت دین صورت زردشت کشتی

چون خر، نخوری نبات و بر پشت کشتی

گر آینهٔ زشتی تو بنماً

دیوانه شوی، در آینه مشت کشتی

</div>

Baa soorat-e deen, soorat-e zardasht keshee
Chon khar, nakhoree nabaat-o, bar posht keshee
Gar aayene, zesht̲iye toraa benmaayad
Divaane shavee, bar aayene mosht keshee

*with | the face of | religion (dogma) | face of | yellow/sallow of him | you kill*
*like | a donkey | you don't eat | sugar candy and | on the | back | you carry*
*if | the mirror | ugliness of | you | it reveals*
*mad | you become | at | the mirror | a punch | you blow*

With the face of religion you kill the ashen-faced lovers.
Like a donkey, you don't eat sweets—you carry them on your back.
If the mirror reveals your ugliness,
You become mad and punch the mirror.

1828 UT

تا چند ز جان ستمند اندیشی
تا کی ز جهان پر گزند اندیشی
آنچ از تو توان ستد همین کالبدست
یک مزبله گو مباش چند اندیشی

<div align="center">◈</div>

Taa-chand ze jaan-e mostamand, andeeshi?
Taa kei ze jahaan-e por gazand, andeeshi?
Aanch az to tavaan setad, hameen kaalbodast
Yek mazbale goo mabash, chand andeeshi?

<div align="center">◈</div>

*how long | of/about | life of | afflicted | you think*
*till | when | of/about | the world of | full | of harm | you think*
*what | of | you | it can | seize/take | this | body it is*
*one | rubbish | say | don't be | how long | you think*

<div align="center">◈</div>

How long will you think about this painful life?
How long will you think about this harmful world?
The only thing it can take from you is your body.
Don't say all this rubbish and stop thinking.

1842 UT

جان در ره ما بباز، اگر مرد دلی
ورنی سر خویش گیر، کز ما بحلی

آن ملک کسی نیافت از نیم دلی
حق می طلبی و مانده در آب و گلی

❖

Jaan dar rah-e maa bebaaz, agar mard-e delee
Varnee sar-e kheesh geer, kaz maa behelee
Aan molk kasee nayaaft, az neem delee
Hagh meetalabee, va maandeh dar aab-o gelee

❖

*life/soul | in | path of | me/us | lose | if | you man of | heart you are*
*if not | the head of | yourself | hold | for of | me/us | you are pardoned*
*that | land | a person | didn't find | of | half | heartedness*
*the truth | you seek | and | stuck | in | water and | mud you are*

❖

You will lose your life on our path if you are a man of the heart
If not, hold your head in grief, you are pardoned by us.
That land cannot be found through doubt—
It is like seeking the truth while being stuck in mud!

1854 AK

---

Dar baa<u>di</u>yeye eshgh-e to, kardam safari
Taaboo ke biyaabam, ze vesaalat khabari
Dar har manzel, min<u>haa</u>dam ghadamee
Afkandeh tanee deedam-o, oftaadeh sari

---

in | the desert of | love of | you | I did | a travel
with the hope | that | I can find | of | merging with you | a news
in | every | house | I took | a step
scattered | a body | I saw and | fallen | a head

---

I travelled in the desert of your love
Hoping to find a word about uniting with you.
In every house I entered,
I saw bodies scattered about and heads fallen to the floor.

1864 UT

گر در طلب منزل جانی، جانی
گر در طلب لقمهٔ نانی، نانی
این نکتهٔ رمز اگر بدانی، دانی
هر چیز که در جستن آنی، آنی

❖

Gar dar talab-e manzel-e jaanee, jaani
Gar dar talab-e logh<u>me</u>ye naanee, naani
In nokteye ramz agar bedaanee, daani
Har cheez ke dar jostan-e aanee, aani

❖

*if | in the | search/want of | home of | the soul you are | you are the soul*
*if | in the | search/want of | a morsel of | bread you are | you are the bread*
*this | point of | secret | if | you know | you know*
*any | thing | that | in the | seek of | that you are | you are that*

❖

If you are in search of the place of the soul, you are the soul.
If you are in search of a morsel of bread, you are the bread.
If you know this secret, then you know
That whatever you seek, you are that.

1881 UT

شمعیست دل مرد براوروختنی

چاکیست زهجر دوست بردوختنی

ای بی خبر از ساختن و سوختنی

عشق آمدنی بود نه آموختنی

Sham'eest del-e mard, barafrookhtani
Chaakeest ze hejr-e doost, bardookhtani
Ey bee khabar az, saakhtan-o sookhtanee
Eshgh aamadanee bood, na aamookhtani

*it is a candle | the heart of | [a] man | [that needs] to be kindled*
*there is a slit | of | separation of | the friend | [that needs] to be stitched*
*O | without | news | of | endurance and | burning you are*
*love | [need] to come [by itself] | not | to be learned*

There is a candle in the heart of man, waiting to be kindled.
In separation from the Friend, there is a cut waiting to be stitched.
O, you, ignorant of endurance and the burning fire of love—
Love comes of its own free will, it can't be learned in any school.

1888 UT

گر خار بدین دیدهٔ چون جوی زنی

ور تیر جفا بر دل چون موی زنی

من دست ز دامن تو کوته نکنم

گر همچو دفم هزار بر روی زنی

Gar khaar, bedeen deedeye chon joy zanee
Var teer-e jafaa, bar del-e chon moy zanee
Man dast ze daaman-e to, kotah nakonam
Gar hamcho dafam hezaar baar, roy zanee

*if | thorn[s] | to these | eyes | like | stream | you stab*
*or if | arrow[s] of | unkindness | at the | heart of | like | strand of hair (weak) |*
*you strike*
*I | hand[s] | of | skirt of | you | short/let loose | I won't do*
*if | like | frame drum | a thousand | times | [my] face | you strike*

You can bring tears to these eyes by striking them with thorns,
You can make this heart, weak as a string of hair, the target of your
arrows of unkindness.
I will not let loose of your garb
Even if you hit my face, like a daf, a thousand times.

1889 UT

Goftam, "Sanami shodee, ke jaanraa vatanee"
Goftaa ke, "Hadees-e jaan makon, gar ze manee"
Goftam ke, "Beteegh-e hojjatam, chand zanee?"
Gofta ke, "Hanooz aashegh-e kheeshtanee"

*I said | an idol/sweet heart | you have become | that | for the soul | you are the
mother land*
*he said | that | discourse of | the soul | don't do | if | of | me you are*
*I said | that | with the blade of | argument/reason to me | how often | you cut*
*he said | that | still | in love with | yourself you are*

I said, "You have become like an idol for me, O you, the Motherland of
the soul."
He said, "Don't discuss the soul if you are one of my own."
I said, "Why do you always cut me with the blade of reason?"
He said, "It seems you are still in love with yourself."

1895 UT

اى آنک مرا بسته ٔ صد دام کنی

گوئى که برو در شب پيغام کنى

گر من بروم، تو با که آرام کنى

هم نام من اى دوست کرا نام کنى

❖

Ey Aank maraa, basteye sad daam koni
Gooyee ke, "Boro" Dar shab, peighaam koni
Gar man beravam, to baa ke aaraam koni?
Ham naam-e man ey doost, keraa naam koni?

❖

*O | you that | to me | bonded/tied up of | a hundred | trap | you do*
*you say | that | go | in | the night | message/page | you do/send*
*if | I | go | you | with | whom | calm/relax/rest | you do*
*same | name of | me | O | friend/Beloved | which person | name | you do/call*

❖

You tie me up to a hundred traps.
You send me messages in the night to leave you alone.
If I go, who will make you feel safe and warm?
O Beloved, who has the same name as me? Who will come when you call?

1900 UT

Man baadam-o to barg, nalarzee che koni?
Kaaree ke manat daham, navarzee che koni?
Chon sang zadam, sabooye to beshkastam
Sad gohar-o sad bahr, narizee che koni?

*I | am the wind and | you | a leaf | [if] you don't shake | what | will you do
the task | that | I to you | I give | you don't exercise/cultivate | what | will you do
when | a stone | I throw | the pitcher of | you | I break
a hundred | jewels/gems and | a hundred | seas | you don't pour | what | will
you do*

I am the wind and you are a leaf. If you don't shake, what will you do?
I grant a task. If you don't perform, what will you do?
When I break your pitcher with a thrown stone,
If a hundred seas and a hundred treasures don't pour out, what will
you do?

1903 UT

Maah aamad peesh-e oo, ke to jaan-e manee
Goftash ke, "To kam<u>ta</u>reen gholaa<u>maa</u>ne manee"
Har-chand bedaan jam', takab<u>bor</u> meekard
Midaasht tama' ke gooyamash aan-e mani

moon | came | near | him | that | you | life/soul of | mine you are
he said | that | you | the least | servants/slaves of | mine you are
because | to that | group/followers | pride | he had
he had | greed/was expecting | that | I say to him | that of (the main thing for me) | mine you are

The moon sat by His side and said, "You are my soul."
The Beloved said, "You are my lowest servant."
The moon was so proud of his admirers,
He was hoping to hear me say, "You are my greatest subject."

1905 UT

*بی من منم و نی تو توی، نی تو منی*

*هم من منم، و هم تو توی هم تو منی*

*من با تو چنانم، ای نگار ختنی*

*که اندر غلطم، که من توم یا تو منی*

◈

Nee man manam-o, nee to to<u>ee</u>, nee to mani
Ham man manamo, ham to to<u>ee</u>, ham to mani
Man baa to chenaanam, ey negaar-e khotni
Ke andar ghalatam, ke man to<u>am</u>, yaa to mani

◈

*neither | I | am I | nor | you | are you | nor | you | are me*
*also/not only | I | am I | but also | you | are you | also | you | are me*
*I | with | you | am in such a way | O | mistress from | Tatar (Mongolia)*
*that | in the | wrong/mistake I am | that | I | am you | or | you | are me*

◈

Neither I am me nor you are you nor you are me.
Also, I am me you are you and you are me.
I am so close to you, O, my Mongolian mistress
That I am confused whether I am you or you are me.

1908 UT

گفتم : چونی؟ مها، خوشی؟ محزونی؟

گفتا : " مه را که بپرسد چونی؟

چون باشد طلعت مه در دونی

تابان ولطیف وخوبی وموزونی

Goftam, "Chonee? Mahaa, Khoshi? Mah<u>zoo</u>ni?
Goftaa, "Mahraa kasi beporsad chooni?
Chon baashad tal'at-e mah, gardoonee
Taabaan-o lateef-o, khoobiyo mozooni"

*I said | how are you | O [my] moon | are you happy | are you sad*
*he said | the moon | anyone | asks | how are you*
*this way/same way | is | the countenance/face of | the moon | turning/orbiting*
*to radiate and | soft/delicate and | goodness and | harmonious*

I said, "How are you, my moon, are you happy? Are you sad?
Moon said, "Should anyone ask of my condition?
This is the countenance of the moon,
Radiating a soft, harmonious and healing glow."

1910 UT

بیرون نگری صورت انسان بینی

خلقی عجب از روم و خراسان بینی

فرمود که ارجع رجوع این باشد

بنگر بدرون که بجز ایشان بینی

◈

Beeroon negari, soorat-e ensaan beenee
Khalghee ajab az, rom-o khoraasaan beenee
Farmood ke erjeaa-e-rojoo', een baashad
Bengar bedaroon, ke bejoz eeshaan beenee

◈

*outside | you look | the face of | human beings | you see*
*people | strange | of | Rome and | Khorasan | you see*
*he proclaimed | that | the reference | [to] this | it is [this]*
*look | to the inside | [so] that | besides | these people | you'll see*

◈

You look outward and you see the human faces
Strange people from Rome and Khorasan.
The Beloved proclaimed, "The lesson here is
To look inside so you can see things beside these people."

جانا زتو بیــزار شوم؟! نی نی نی

با جـــز تو دگر یارشوم؟! نی نی نی

در باغ وصالت چوهمـه گل بینم

سرگشته بهـــر خار شوم؟! نی نی نی

Jaanaa ze to beezaar shavam? Nee, nee, nee
Baa joz to, degar yaar shavam? Nee, nee, nee
Dar baagh-e vesaalat, cho hame gol beenam
Sargashte behar khaar shavam? Nee, nee, nee

*O soul/my soul | of | you | disgusted/fed-up | [would] I become | no | no | no*
*with | except | you | again | a lover | [would] I become | no | no | no*
*in the | garden of | your union | where | all | flower/rose | I see*
*bewildered | to any | thorn | [would] I become/go | no | no | no*

O my soul, would I ever become fed up with you? No, no, no.
Would I ever take another lover but you? No, no, no.
In your garden of union, when all I see are roses,
Would I ever rush toward the thorns? No, no, no.

1921 UT

<div dir="rtl">

ای نسخهٔ نامهٔ الهی که توی

وی آینهٔ جمال شاهی که توی

بیرون ز تو نیست هر چه در عالم است

در خود بطلب هر آنچ خواهی، که توی

</div>

Ey nos<u>kh</u>eye naameye elaahee, ke to<u>ee</u>
Vey aaye<u>n</u>eye jamaal-e shaahee, ke to<u>ee</u>
Beeroon ze to neest, harche dar aalam hast
Dar-khod betalab har aanche khaahee, ke to<u>ee</u>

*O | a copy of/same as | letter of | consciousness/godly | that | you are*
*and O | mirror of | face of | kingly/regal | that | you are*
*outside | of | you | it is not | any thing | in the | world | it is*
*inside yourself | seek | every | thing | you wish | that/because | you are*

You personify God's message.
You reflect the King's face.
There is nothing in the universe that you are not
Everything you want, look for it within yourself—you are that.

1923 UT

ای خواجه زهر خیال پر باد شوی

و ز هیچ ترش گردی و دلشاد شوی

دیدم که در آتشی و بگذاشتمت

تا پخته و تا زیرک و استاد شوی

◈

Ey khaaje, ze har khi<u>yaa</u>l por baad shavi
Vaz heech torsh gard<u>ee</u>-o, delshaad shavi
Deedam ke dar aata<u>shi</u>yo, bogzaa<u>sh</u>tamat
Taa pokh<u>te</u>-o, taa zeerak-o ostaad shavi

◈

*O | wise person | of | every | fantasy | full of | air (pride) | you become*
*and of | nothing | sour | you become and | joyful | you become*
*I saw | that | in the | fire you are and | I let you stay*
*until | baked and | until | shrewd and | a master | you become*

◈

O wise one, you inflate with every little fantasy
For no good reason, you turn sour or become happy.
I see you amidst the flames yet I let you stay
Until you become baked, shrewd, and a master yourself.

1937 UT

گه با هاروت ساحر اندر چاهی

گه در دل زهره پاسبان ماهی

Jaan rooz cho maarast-o, beshab chon maahi
bengar, ke to baa kodaam jaan, hamraahi
Gah baa haaroot-e saaher, andar chaahee
Gah dar del-e zohre, paasebaan-e maahi

*soul/life | daytime | like | a snake it is and | at night | like | a fish*
*look | that | you | with | which | life/soul | you are traveling with*
*at times | with | Haroot | the sorcerer | inside | a well you are*
*at times | in the | heart of | Venus | the police/watch person of | the moon you are*

The soul is like a snake during the day and like a fish at night.
Open your eyes and realize which is your travelling companion.
At times you are with Haroot the Sorcerer, deep in a well.
At times you reside in the heart of Venus, watching over the Moon.

دستار نهـاده ، به مطرب ندهی

دستار بده ، تا ز تکبر برهی

خود را برهان ، زانکه تو دستار نهی

دستار بده ، عوض ستان تاج شهی

◈

Dastaar nahaade'i, bemotreb nadahee
Dastaar bedeh, taa ze ta<u>kab</u>bor berahee
Khodraa berahaan, zaanke to dastaar nahee
Dastaar bedeh, avaz setaan taaj-e shahee

◈

*turban | you have wrapped/placed | to the musicians (or any body else) | you don't give*
*turban | you give | until | of the | pride/ego | you escape*
*yourself | rescue | because | you | turban | are not*
*turban | you give | in exchange | take back | crown of | a king*

◈

You are wearing a turban and you won't give it to the musicians
Give away that turban and let your pride go with it!
Rescue yourself from what you have no control over!
Give that turban and in return receive the crown of a king.

1945 UT

اى بانگِ رباب، از كجا مى آيى؟

پر آتش و پر فتنه و پر غوغايى

جاسوس دلى و پيكِ آن صحرايى

اسرارِ دلست، هر چه مى فرمايى؟

<hr>

Ey baang-e robaab, az kojaa mi<u>aa</u>i?
Por aatash-o, por fet<u>ne</u>-o, por gho<u>gha</u>i
Jaasoo<u>s-e</u> delee, va peik-e aan sah<u>raa</u>i
As<u>raar</u>-e delast, harche meefar<u>maa</u>i

<hr>

*Oh | sound of | rubaab | of | where | are you coming*
*full of | fire and | full of | seduction and | full of | turmoil you are*
*spy of | the heart you are | and | the messenger of | that | desert (heavenly lands)*
*you are*
*The secrets of | the heart it is | whatever | you proclaim*

<hr>

Oh, sound of rubaab, where are you coming from?
You are so fiery, tempting, and full of turmoil,
You are the spy of the heart and the messenger of heavenly lands
Whatever sound you make is the secret of the heart.

<u>1950 UT</u>

Doosh aamad yaar, bardaram shey<u>daa</u>yi
Goftam ke, "Bero ke emshab, andar naayi"
Meeraft-o-hamee goft, "zahee sodaayi
Dolat bedar aamadast, dar nag<u>shaa</u>yi

*last night | came | the Beloved/Lover | at my door | frenzied [with love]*
*I said | that | go | because | tonight | inside | you won't come*
*while he was leaving | he said | great | passion/devotion*
*wealth/country/state | at the door | has come | the door | you don't open*

Last night the Beloved came to my door frenzied with love.
I said, "Go away. Tonight you are not coming in."
On His way out He said: "So this is your devotion,
The world has come to your door, and you don't open it."

1977 UT

Gofti ke, "To divaane-o, majnoon khooyee"
Divaane to<u>ee</u>, ke agh'l az man jooyee
Goftee ke, "Che beesharm-o che aahan rooyee"
Aa<u>ee</u>ne konad hameeshe, aahan rooyee

*you said | that | you | mad and | a crazy | disposition you have*
*mad | you are | that | intellect | of | me | you seek*
*you said | that | how | shameless and | how | iron | face you are (unabashed*
*dauntless/with a cold face)*
*mirror | does | always | iron | face behavior (unwavering truth)*

You said, "You are mad and have the disposition of a lunatic."
You are mad yourself, for you are asking wisdom from me.
You said, "How shameless! You show no trace of emotions."
A mirror always shows the absolute truth.

1980 UT

Ey baad-e sahar, to az sar-e-nikooyee
Shaayad-ke, hekaayatam bedaan mah gooyee
Nee nee ghalatam, garat bedoreh boodee
Pas gerd-e jahaan, degar-keraa mijooyee

*O | breeze of | morning/dawn | you | of | out of kindness*
*perhaps | my legend/story | to that | moon (the Beloved) | you [will] say*
*no | no | I am wrong | if you | in the circle/gathering (one of us) | you were*
*then | around the | world | who else | you are seeking*

O morning breeze, out of kindness
Perhaps you could tell my story to the moon.
No, no, I am wrong, if you were one of us
Then who are you still seeking, spinning around the world?

1987 AK

هر کس کسکی دارد و هر کس یاری

هر کس هنری دارد و هر کس کاری

مائیم و خیال یار و این گوشهٔ دل

چون احمد و بوبکر به گوشهٔ غاری

⬧

Har kas ka<u>sa</u>kee daarad-o, har kas yaari
Har kas ho<u>na</u>ree daarad-o, har kas kaari
Maa<u>ee</u>m-o khiyaal-e yaar-o, een go<u>she</u>ye del
Chon ahmad-o bobakr, be<u>goo</u>sheye ghaari

⬧

*every | person | someone | he has and | every | person | a lover*
*every | person | a craft | he has and | every | person | a profession*
*I am and | the fantasy of | the Lover and | this | corner of | the heart*
*like | Ahmad (Mohammad) and | Abobakr | in the corner of | a cave*

⬧

Everyone has someone and everyone has a lover
Everyone knows a craft and everyone has a profession
But all I have is the dream of the Lover and the corner of my heart,
Like Ahmad and Abobakr in the corner of the cave.

# GLOSSARY OF TERMS

**Darvish:** (Dervish) A Persian word for one who has renounced the world. Certain Darvish orders of Iran trace their heritage back to the pre-Zoroastrian order of the Mithra. Their system of belief is based upon rigorous exercises, devotional movements, chants, proper diet, meditation, whirling, and non-attachment to the material properties of the world. They believe that the word Yoga is the derivative of the Persian word Yegane (oneness, unity). They also see a distinct difference between a Darvish and a Sufi, although in many mystical orders of Islam the words Darvish and Sufi are used interchangeably.

**Haaroot:** Haaroot and Maaroot are two angels who complained to God about the fickleness of human nature. They were then given human bodies to prove that they could be more disciplined humans. After receiving their new bodies, their behavior was similar to the people they had criticized.

**Ka'be:** The Muslim place of pilgrimage. A black cube-shaped shrine in the city of Mecca, Saudi Arabia.

**Khezr:** The immortal Green-Being, mentioned in the Koran, whose vision alone grants the seeker immortality.

**Konya:** (Ghoniye in Persian) A city in modern day Turkey, and the location of Rumi's shrine. The area where Rumi spent the majority of his adult life.

**Moulana:** Our master. Rumi's title.

**Oxus River:** An old name for the Amu Darya River which runs along the borders of Turkmenistan and Tajikistan into Afghanistan.

**The Prophet:** Mohammad, founder of Islam.

**Rubaab:** A type of lute, played in Afghanistan.

**Saaghi:** Cup bearer. In the poetry of Rumi, Saaghi is the metaphor for the moment one is enraptured by a divinely-induced state of ecstasy. When one is experiencing this state, one says that the Saaghi has brought the wine of love.

**Samaa:** In the poetry of Rumi, Samaa refers to the whirling dance of the Darvishes. This sacred movement is offered to, and symbolizes the constant movement of, the universe. From the smallest atoms to the galaxies—all are subject to rotation. Darvishes believe that the human body is no exception, and through whirling one harmonizes with the energy of the creation.

**Shams-e Tabriz:** (Lit.: Shams from Tabriz) Rumi's spiritual friend who became the conduit for transformation for Rumi. Because of this, Rumi worshiped him. Shams also means the sun. His full name is Shamsuddin Mohammad-ebne Ali-ebne Molkdad.

**Sufi:** A mystic of Islam. Sufism traces its origins to Imam Ali, Prophet Mohammad's son-in-law, who is considered to be the first Sufi. Certain mystical orders of Iran believe that a Sufi is the one who is seeking the path, hence the many references to Sufis as wayfarers. Whereas Aaref (mystic) is the one who has found the path. Therefore, a Sufi is a seeker and an Aaref is a knower of the path. In many spiritual orders of Islam the words Sufi and Darvish are used interchangeably.

**Two worlds:** Here and hereafter. This world and the next. Heaven and Earth.

**Water of life:** The inner nectar of immortality. The nectar that holds the essence of the creation. Described as a spring that one encounters in meditation.

# PERSIAN MYSTICAL TERMINOLOGY AND REFERENCE GUIDE

**Ashen-faced lover:** (also sallow faced) In poetry of Rumi, the lover or seeker's face is always referred to as ashen, sallow, pale. It is only the Beloved who has a face as bright and vibrant as a rose. Persian: Rokh-e Zard = yellow face. Poems: 225UT, 986AK, 1502UT, 1825UT.

**Beloved:** God, perceived as one's closest friend, companion, and a lover. A universal mystical concept. The following Persian words can be translated as the Beloved. Doost = friend; Yaar = companion; Sanam = idol; Delbar = heart-stealer, sweetheart; Jaanaan = dearest. Poems: 171AK, 245AK, 285AK, 319AK, 511AK, 1153AK, 1154 AK, 1256AK, 1552UT, 1722AK, 1776UT, 1915UT.

**Breeze:** The life-giving breath of the Beloved. Persian: Baad = wind; Baad-e Sabaa = breeze of dawn; Baad-e Bahaar = breeze of spring. Poems: 466AK, 646UT.

**Burning:** The pain that follows the process of spiritual growth and purification. Persian: Sookhtan = burning. Poems: 211UT, 452UT, 616UT, 785AK, 844UT, 1301AK, 1372UT, 1449UT, 1506UT, 1815UT, 1881UT, 1923UT.

**Crow:** a Dark force. In the poetry of Rumi the word crow if often used as the opposite to nightingale. Persian: Zaagh = crow, raven. Poem: 1055AK.

**Drunkenness:** Being enraptured by the love of God. A divinely-induced feeling of ecstasy. Persian: Mastee = drunkenness; Kharabee = dead drunk. Poems: 82UT, 223UT, 344AK, 577UT, 684AK, 791UT, 1254UT, 1322UT, 1372UT, 1634UT.

**Garden:** A metaphor for a beautiful and harmonious state of being. Also used literally as a flower field. Persian: Baagh = orchard; Baaghche = garden; Golshan = flower field; Golzaar = flower field. Poems: 64UT, 300UT, 319UT, 1004UT, 1055AK, 1504AK, 1776UT, 1915UT.

**Hair:** The state of being in the Beloved's presence has been described as being caught in the Beloved's beautiful net-like hair. It can also mean illusion. Persian: Moo = hair; Zolf = hair; Zolf-e cho shast = Hair like a net. Poems: 264UT, 809AK, 1135UT, 1289UT.

**Killing:** The destruction of one's ego and its limited sense of identity. It especially refers to the breaking of one's attachment to the physical body. Persian: Koshtan = killing; Fanaa = annihilation. Poems: 557UT, 577UT, 679AK, 800UT, 842AK, 930UT, 986AK, 1190AK, 1316UT, 1854AK.

**King:** God, the Beloved. Persian: Shah = king. Poems: 776UT, 1938UT.

**Nightingale:** The soul singing to the Beloved. Persian: Bolbol = nightingale. Poems: 319UT, 1055AK.

**Ocean:** The universe, the plain of consciousness that needs to be crossed so one can attain self-realization. Persian: Daryaa = sea; Baadiye = desert. Poems: 232AK, 779AK, 1854AK.

**Pearl:** Represents maturation and completion of one's character. Persian: Dorr = pearl. Poem: 805UT.

**Rose:** The eternal and perfect beauty of the Beloved. In Rumi's poetry the word thorn is used as the opposite of rose. Persian: Gol = flower, rose. Poems: 319UT, 579UT, 646UT, 1055AK, 1504AK, 1695UT, 1776UT, 1915UT.

**Sorrow:** The pain of being away from one's loved one. In the poetry of Rumi, the pain of separation from God. Persian: Gham = sorrow. Poems: 211UT, 351UT, 435UT, 447AK, 651AK, 693AK, 912AK, 1089UT, 1186AK, 1265UT, 1449UT, 1482UT, 1515AK, 1788UT.

**Wedding Night:** The night the soul (lover) joins in union with God (the Beloved). It also refers to the day a great saint leaves his/her body. Persian: Nesaar = call to a wedding; Vas'l = union, marriage. Poems: 130UT, 319AK.

**Wine:** Nectar of love; divinely intoxicating presence of the Beloved. Persian: Mei = wine; Baade = wine. Poems: 9AK, 82UT, 130AK, 306AK, 311AK, 318UT, 344AK, 485AK, 684AK, 1019UT, 1028AK, 1106UT, 1159AK, 1322UT, 1575UT, 1636UT.

# BIBLIOGRAPHY

Furuzanfar, Badiuzzaman, *Kulliyat-e Shams-e Tabrizi*. Tehran: Amir Kabir Press, 12th edition, 1988.

Furuzanfar, Badiuzzaman, *Kulliyat-e Shams,* Tehran: University of Tehran, First Edition, 1963, Vol. 8.